# BETWEEN HEAVEN AND EARTH

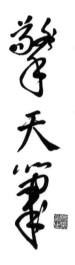

# BETWEEN

# HEAVEN

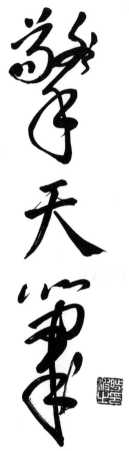

Shi Bo

# AND EARTH

## A HISTORY OF
## CHINESE WRITING

*Translated by Sherab Chödzin Kohn*

SHAMBHALA · *Boston & London* · 2003

Shambhala Publications, Inc.
Horticultural Hall
300 Massachusetts Avenue
Boston, Massachusetts 02115
*www.shambhala.com*

Previously published as *Entre Ciel et Terre: Sur les Traces
de L'Écriture Chinoise* ©2000 by Éditions Alternatives,
Paris, France
English translation © 2002 by Shambhala Publications, Inc.

9 8 7 6 5 4 3 2 1

First Shambhala Edition
Printed in the United States of America

⊗ This edition is printed on acid-free paper that meets
the American National Standards Institute z39.48 Standard.
Distributed in the United States by Random House, Inc.,
and in Canada by Random House of Canada Ltd

Library of Congress Cataloging-in-Publication Data
Shi, Bo.
[Entre ciel et terre. English]
Between heaven and earth: a history of Chinese writing / Shi
Bo; translated by Sherab Chödzin Kohn.—1st Shambhala ed.
p. cm.
ISBN 1-59030-050-55
1. Calligraphy, Chinese—History. 2. China—History I. Title.
NK3634.A2 S53413 2003
745.6'19951—dc21
2003002497

# CONTENTS

# Foreword

CHINESE WRITING has a long history of evolution and refinement, one that is entirely unique compared to the other ways of writing humanity has developed. Today, the artistic nature of this writing remains one of the aspects of the soul of my country.

Like the Chinese language, Chinese writing is not alphabetical; it is composed of ideograms, in which each character represents a syllable that communicates a precise idea. The number of characters, according to researchers in linguistics and calligraphy, reaches fifty thousand; but in the common language, only three thousand signs are in frequent use.

This mode of writing has passed through seven important stages of evolution, which I will present in this book, illustrating them through calligraphic characters and providing historical and legendary anecdotes as well. In addition, in order to make my account of this development easier to read and understand, it seemed necessary to introduce it with a brief overall presentation of the Chinese system of writing.

Finally, it should be made clear that in the Chinese sense of the term, writing is not equivalent to calligraphy, and knowing how to write is by no means all that is needed to be a calligrapher. Just like traditional Chinese painting, Chinese calligraphy is known throughout the entire world as a full-fledged art on its own, with an incontestable esthetic quality. For centuries many Chinese have devoted

their entire lives to mastering this difficult discipline. Their works, which are very much sought after, are found in the world's museums alongside those of the greatest painters and sculptors.

SHI BO
*Spring 1999*
*Solitude Pavilion, Ivry-sur-Seine*

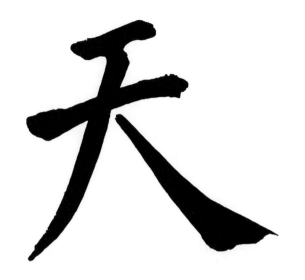

# 1 THE SYSTEM OF CHINESE WRITING

# Forms of Composition

It is true that Chinese characters are complicated, but they are not as difficult to grasp as one might think, because they are part of a system of writing that is logical and scientific, and that observes a certain number of principles of composition.

According to Chinese etymologists and calligraphers, nearly fifty thousand characters can be classified in terms of six forms of composition with the general designation of *Liushu*.

## Xiangxing
*(pictograms)*

The *Xiangxing* were originally drawings of animals and concrete objects. As they evolved, they became ordinary characters. Let us look at two examples.

*First Example:*

 In the most ancient Chinese writing, this form represented a bow used by the ancients for hunting. Over time, the string on the right disappeared and the word underwent the following transformations:

*Second Example:*

This pictographic character represented a horn with scratch marks running across it—works of nature. It meant and still means "the horn," with the sole difference that in antiquity, two other meanings were attributed to it: "jug of wine" and "musical instrument." This character underwent a number of modifications, of which the most important are the following:

## Zhishi
*(ideograms)*

As it developed further, primitive society was no longer able to confine itself to concrete pictograms because the ancients also sought to express abstract ideas. For this reason representative symbols arose that progressively turned into ideograms.

We can cite two examples:

*First Example:*

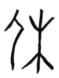 This ideogram is clearly composed of two distinct parts. The upper part represents a watchtower whose top points to the sky, and the lower part symbolizes the Great Wall or a surrounding wall with an entrance door in the middle of it. It has an abstract meaning: "high." The form of this character has undergone few changes:

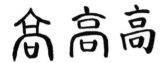

*Second Example:*

This character has two elements, which originally signified a deep ditch open to the sky and a careless hunter who has fallen into it. It had and still has the meaning of "danger," "menace," "malevolent," etc.

# Huiyi

*(composite ideograms)*

A large number of ideograms are composed of two or several character components. This new method of organization made it possible to create new words.

*First Example:*

 In the initial form of this character, a tired man (left-hand part) leaned against a tree (right-hand part) to rest. This character meant, and continues to mean, "rest."

By extension, today it also has other meanings, such as "happiness," "not," "stopping (an activity)," etc. Let us examine more closely the major stages of evolution of its form:

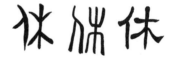

*Second Example:*

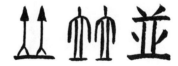 Originally, this ideogram was composed of two men standing side by side. It meant just that—"side by side," or "together," and its form underwent major changes:

# XINGSHENG

*(composite phonetics)*

In Chinese, *Xingsheng* means "form plus sound" and refers to Chinese characters that result from putting together a visual semantic component with a phonetic component.

*First Example:*

This character has an upper part that means "take" and a lower part that represents "woman"; the whole character thus means "to take a wife." The upper part makes the pronunciation of the character "Qu." The principal forms of evolution of this character are the following:

*Second Example:*

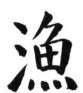

In ancient times, this character exhibited different forms, of which the most important is this one:

It evoked a fish (the left part) in the water (the right part), or a fish captured by a hand or a net. Over time, only the first interpretation was preserved, and the positions of the two parts were reversed:

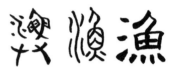

This word is connected with all equipment having to do with fishing.

# ZHUANZHU

*(transferred characters)*

Opinions differ on this form of composition. In general, linguists and philologists believe that the *Zhuanzhu* present, in a new written form, characters whose pronunciation has progressively changed in an effort to better express a new sound. For example, the character *Kai* (right) is a transfer from the original *Qi* (below):

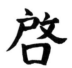

The character *Kai* was especially created to better reflect a new pronunciation that developed from

the former character *Qi*. Today, these two words have the same meaning: "open," "begin," etc.

Another example is the character *Hua*:

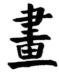

This character comes from the word *Hui*.

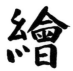

Hua came into use in order to give a new pronunciation and a new form to its original, *Hui*. Both mean "to draw (a picture)."

## JIAJIE
### *(borrowed characters)*

In order to develop and enrich the Chinese language and way of writing, the ancients borrowed or took over a large number of existing characters to create new words that had nothing to do with the initial meaning of those original characters but which were intimately linked to them by phonetic resemblance. This is the case with the character *Bei*.

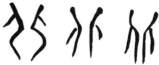

Originally, it was written like this:

It represented two people standing back to back and in the ancient books signified "the back." But over time this word was taken over and used to designate "north," while still keeping the pronunciation *Bei*. In the interest of avoiding confusion, a new composite word was created of which the upper part is 北 (*Bei*, the north) and the lower part is 月 (*rou*, flesh). Since then, this character has replaced 北 to designate "the back," while 北 , which originally meant "the back," now means "north."

Another example is *Dong*.

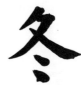

The original meaning of this character was "the end." In the most ancient books, it was written in the form of a string whose two ends ended in knots:

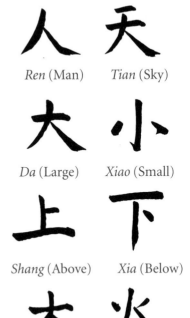

But on the left was added a radical 糸 , meaning "silk," resulting in a new quasi-homophonous character, *Zhong*.

This derivative character took on the meaning of the word *Dong* ("the end"), while the original character 冬 henceforth meant "winter."

Let us look at a third, more complicated, example: *Zhi*. In the beginning, this character was written like a bird caught in a hand and meant "to catch." Later, two elements

meaning, respectively, "dog" and "grains," were added to it:

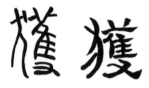

This new character, which is pronounced *Huo*, meant, and still means, "to catch wild animals" and "to obtain good harvests," whereas the borrowed 隻 *(Zhi)* has lost its original meaning and has become a mere qualifier.

# STRUCTURE

In terms of structure, Chinese characters can be divided into two categories.

### Simple Characters

These are characters composed of not very many strokes.

*Ren* (Man)    *Tian* (Sky)

*Da* (Large)    *Xiao* (Small)

*Shang* (Above)    *Xia* (Below)

*Mu* (Tree)    *Huo* (Fire)

## Composite Characters

Most Chinese characters are composed of two or three parts, generally well-structured and organized according to a predefined order.

A—Characters composed of an upper part and a lower part:

Si        Piao        Shuang

B—Characters composed of a left part and a right part:

Shuo        Ru        Fan

C—Characters composed of an inner part and an outer part:

Wang        Yan        Mi

D—Characters composed of an upper part, a central part, and a lower part:

Mo        Bin        Hui

E—Characters composed of a left part, a central part, and a right part:

Jie        Ji        Shu

## Radicals

Over time, the most frequently used component parts became radicals, or keys. According to the *Dictionary of Contemporary Chinese,* which is considered authoritative in China, fifty-three of them exist; according to the Centenaire editions published in Paris, there are 214. The following pages present the most commonly used radicals.

| RADICALS | NAME | EXAMPLES |
|---|---|---|
| 山 | *Shan* (mountain) | 屹 岑 盆 岚 |
| 日 | *Ri* (sun) | 旦 旬 旭 时 |
| 鸟 | *Niao* (bird) | 鸠 鸥 鳯 鹛 |
| 虫 | *Chong* (insect) | 虬 蛇 虹 蚁 |
| 冫 | *Liangdianshui* (ice) | 次 冷 准 冲 |
| 氵 | *Sandianshui* (water) | 江 流 浩 澎 |
| 讠 | *Yanzipang* (speech) | 计 论 识 诊 |
| 刂 | *Lidaopang* (knife) | 列 别 剑 到 |
| 厂 | *Pianchang* (cliff) | 厅 历 厚 厕 |
| 匚 | *Sankuang* (basket) | 区 匠 匣 巨 |
| 宀 | *Tubaogai* (to cover) | 写 军 冠 家 |
| 冂(冂) | *Tongzikuang* (border) | 网 冈 周 同 |
| 亻 | *Danliren* (man alone) | 你 他 仁 位 |
| 勹 | *Baozitou* (envelope) | 匀 勾 匀 甸 |
| 廴 | *Jianzhipang* (construction) | 廷 延 建 迫 |
| 卩 | *Dan'erpang* (bucket) | 卫 印 却 即 |
| 阝 | *Zuo'erpang* (left ear) | 防 阴 院 阮 |

| RADICALS | NAME | EXAMPLES |
|---|---|---|
| 阝 | *You'erpang* (right ear) | 邦 那 郊 都 |
| 丬(爿) | *Jiangzipang* (plank) | 状 壮 将 状 |
| 忄 | *Shuxipang* (vertical heart) | 怀 情 快 性 |
| 宀 | *Baogai* (roof) | 宇 定 宾 家 |
| 广 | *Guangzipang* (shelter) | 庆 店 庄 席 |
| 辶 | *Zhouzhipang* (to walk) | 过 还 送 迎 |
| 土 | *Titupang* (earth) | 地 场 城 坑 |
| 艹 | *Caotou* (grass) | 花 茶 茗 英 |
| 扌 | *Tishoupang* (hand) | 打 拉 拖 摘 |
| 囗 | *Fangkuang* (enclosure) | 困 图 国 困 |
| 彳 | *Shuangrenpang* (two men) | 從 往 行 征 |
| 夊 | *Zhewen* (to follow) | 冬 处 夏 放 |
| 犭 | *Fanquanpang* (dog standing up) | 狂 狗 独 狠 |
| 饣 | *Shizipang* (food) | 饮 饲 饭 馔 |
| 子 | *Zizipang* (son) | 孔 孙 孩 孜 |
| 纟 | *Jiaosipang* (silk) | 织 红 约 纯 |
| 灬 | *Sidian* (four points) | 杰 点 热 熊 |

| RADICALS | NAME | EXAMPLES |
|:---:|:---:|:---:|
| 火 | *Huozipang* (fire) | 灯丁烛灿灶 |
| 礻 | *Shizipang* (indication) | 神礼社祖 |
| 王 | *Wangzipang* (king) | 玩珍珏玻 |
| 木 | *Muzipang* (tree) | 林板材树 |
| 牛 | *Niuzipang* (bullock) | 牡物牲牧 |
| 疒 | *Bingzipang* (illness) | 病疾痴瘵 |
| 衤 | *Yizipang* (article of clothing) | 被初裤袱 |
| 金 | *Jinzipang* (metal) | 银钢铜铃 |
| 禾 | *Hemupang* (grains) | 和种秋利 |
| 癶 | *Dengzitou* (face-to-face) | 登癸凳镫 |
| 养 | *Juanzitou* (scroll) | 卷券拳眷 |
| 米 | *Mizipang* (rice) | 糠粉料粗 |
| 虍 | *Huzitou* (tiger) | 虎虥房虚 |
| 竹 | *Zhuzitou* (bamboo) | 笠笑笔笛 |
| 𧾷 | *Zuzipang* (foot) | 踢跃距趾 |
| 四 | *Sizitou* (four) | 罗罢罪署 |
| 皿 | *Minzidi* (vessel) | 盂盖盔盅 |

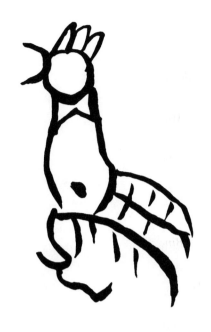

# 2 ORACLE BONE SCRIPT

*Jiaguwen*

I N 1899, IN THE VILLAGE of Xioatung, in the district of Anyang, the province of Henan, in the center of China, a great scholar of Chinese philosophy fell ill one day. This old mandarin, known by the name of Wang Yirong, summoned to his bedside a doctor of the district who prescribed for him a remedy composed of ten medicinal plants and a potion of "dragon's bone."

When his servant came back from the pharmacy with packets of the remedy, he opened one in haste, eager to look and see what this mysterious "dragon's bone" might be. To his great astonishment, he saw pieces of bone and of tortoise shell that bore strange markings resembling writing.

This form seemed to represent the current word "mountain." The other

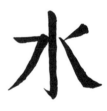

ancient
marking

current written
form

The old mandarin found two other signs that were of particular interest for various reasons.

The first sign rather clearly evoked a horse: we can discern the tail, the head, and the mane covering the back.

The second bore considerable resemblances to the common

character for "wheat."

Driven by curiosity, Wang Yirong at once sent his servant to the

line resembled a word that was used—and is still used today—to designate "water."

pharmacy to buy all of the "dragon bone" and the following day sent for his friend Liu Chang of the archeological academy of Henan to come study the signs,

which he found extremely strange.

Studying the "dragon bones," Liu Chang jumped for joy. He found that in fact they bore the most ancient Chinese writing ever discovered up to that point. He immediately called it *Jiaguwen*, which means in Chinese "writing inscribed on bones and shells."

From this time on, Liu Chang and other scholars devoted themselves to the study of these primitive inscriptions and discovered, on 154,600 pieces of bone and shell, 4,568 pictographic signs, of which only 1,700 have been identified and translated into contemporary language. Here are some examples:

a round surface with a bar in the middle, signifying "the sun;"

 three twigs, crossed and ending with circles, meaning "fruit;"

a drawing resembling a bird, which is, in fact, the word "bird."

As to the following signs, they represent respectively: "man," seen in profile and holding out an arm;

 "fire," symbolized by blazing flames;

"tree," composed of two trees side by side;

"woman" in a graceful posture that evokes the attitude of obedience of ancient Chinese women: kneeling with hands joined in front of the chest;

"drum," illustrating a hand (right part) beating a drum (left part) with a tree branch; the middle of the drum is its round face; the upper part of it seems to be its ornaments, whereas its lower part 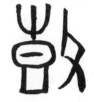 is without doubt the pedestal supporting it;

"the cock." What a strong resemblance between this pictographic sign and the prideful animal we are familiar with! This sign strikes us as much with its elegance as with the lively vigor

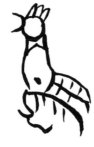

of the bird, which appears to be gathering itself to leap.

Wonderstruck, the scholar Liu Chang told his friend the mandarin Wang Yirong that Jiaguwen had served the ancients for recording oracles and for supplicating to heaven for a good harvest. That is why words with abstract meanings were also found among these pictographic signs, words such as "beauty, represented by a very elegant stag with two harmoniously depicted antlers; or "happi-

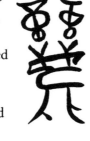

ness," composed on the left top by a jug of wine held by two joined hands below it, and on the right by an altar; it originally signified that someone was offering wine before an altar as a way of praying for the blessing of heaven, "happiness," or "dark," "quiet."

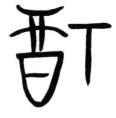

This primitive inscription is composed of an upper part resembling two silk strings and of a lower part symbolizing fire. The flames are too weak to burn the silk, which means that it is a low fire, and it is from this that the meaning of "dark" and "quiet" is derived.

In this pictogram we clearly see a person entering a house; this inscription has been deciphered as meaning "guest."

As an expert in *Jiaguwen*, Liu Chang declared, not without pride, that this first Chinese writing had been magnificent from an artistic point of view, but that it was no longer of any use because very few people any longer knew it.

And, in fact, *Jiaguwen* has still not revealed to us all of its secrets; two-thirds of the signs discovered inscribed on bones and shells have not been deciphered to this day. Yet, Chinese and Japanese scholars

have not made a concerted effort to get them to reveal their meaning for nearly a century.

Recently, my son Shi Qiao, who is a specialist in computer science, wrote me a letter in which he shared an astonishing piece of news.

A fifty-year-old Chinese peasant, with the first name of Li Yun, has invented a new computerized method that makes it possible to decipher this earliest writing with ease.

Over the course of about thirty years, this peasant from the north of China (whose father is an old scholar of *Jiaguwen* and other ancient methods of writing) studied more than four thousand inscribed signs and created a computerized classification by

*A complete animal bone bearing a text in* Jiaguwen *from the Shang dynasty*

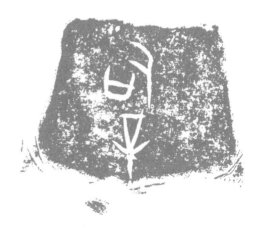

*A fragment of shell bearing two characters meaning "functionary"*

*Text written by a Taiwanese expert in* Jiaguwen

assigning numbers to all the radicals and pictographic components. With his new numerical method, he can easily translate all the signs of *Jiaguwen*. At a conference organized in February 1999 in Shanghai by Chinese academics who are experts in this subject, this peasant proved the effectiveness and the accuracy of his method by responding to all the questions posed to him and tests imposed upon him by the specialists in attendance. This conference unanimously approved his numerical and scientific technique.

It should be noted that most specialists agree that *Jiaguwen* was the first Chinese writing. They estimate that the first markings of this type made their appearance under the Shang dynasty (1711–1066 B.C.E.). In addition, most of them affirm that the first written signs date from about 3,000 or 3,5000 years ago. But a small number of people have a different view. A young Chinese, for example, recently asserted that in reality "markings made by

bird's feet were for the Chinese the first calligraphies." He even went so far as to affirm that "there is also constellation, stars that one links by imagination. And then there are the cracks. . . ."

By this he means to suggest that any line in nature without exception may be considered as the first Chinese calligraphy. I cite him in passing, with all appropriate reserve, leaving it to my readers to make their own judgment on this approach.

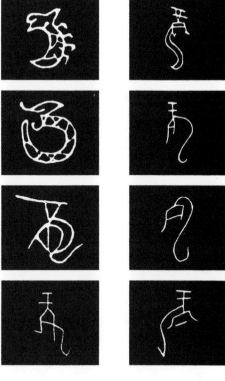

*Various forms of the character "dragon" in Jiaguwen*

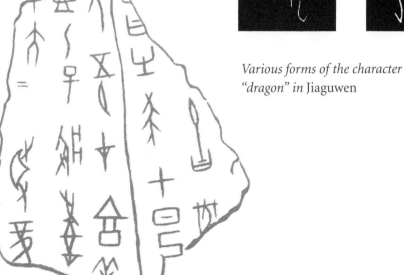

*A fragment of shell bearing inscriptions, a part of which is indecipherable*

# 3 RITUAL BRONZE VESSEL SCRIPT

*Jinwen*

ONE DAY, KING TANG of the Shang dynasty (c. 1750–1040 B.C.E.), an ambitious man intoxicated by his victorious wars, called together his ministers and generals in his splendid palace and announced to them: "After twenty years of war, I have exterminated my adversaries and founded a great kingdom. Whoever has an ingenious idea of what could be done to immortalize my exploits will be generously rewarded."

The ministers and generals looked at each other; they rubbed their hands together, scratched their necks, paced up and down, but remained dumbstruck, not knowing what to say.

At the end of a long and heavy silence, a man came forward with a precise, measured step—it was the chief advisor to the royal court and the minister of religion, Ju Xiaoshi. He swept the high dignitaries present with his tranquil regard before throwing himself at the feet of the monarch and declaring: "Your Majesty, since you have already ordered the casting of bells and tripods in bronze for the royal palace, why not have your famous exploits inscribed on them?"

All those present began to murmur, creating a hubbub of general amazement.

Joy illuminated the face of King Tang.

"Excellent idea! From this moment forth, you are my new prime minister."

Set up in his new residence, Ju Xiaoshi called together his close advisors to compose the words that would best embody the great deeds of his monarch and to create esthetic characters worthy of passing down through history. Very rapidly, the first word was decided upon, both as to its meaning and its form.

*Bei*

It signified "shell," which is what the inhabitants of the kingdom used as money at the time. This had been an important invention of the monarch in developing the commerce of his country. The inventor of the character had another meaning to bestow upon it: the wealth that the king had brought his subjects. The king did not hesitate for a second to approve this proposal.

A military advisor said to the prime minister one day: "In the

course of twenty years of war, our king went from triumph to triumph, and the chariot made a big contribution to this. Our king has chosen it as the symbol for all his military vehicles."

It was thus that the word *Che* (chariot) was invented in its *Jinwen* form and inscribed on many bronze tripods. It is made up of three wheels drawn by two buffalo.

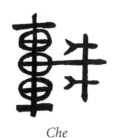

*Che*

Another of the prime minister's advisors, for agriculture, found and created a word to glorify the excellent agricultural policy of His Majesty, the King: Cang recalled that the storehouses, scattered here and there throughout the kingdom, were bursting with grain.

*Cang*

On the day of the fiftieth anniversary of the monarch Tang, the prime minister Ju Xiaoshi presented to his ruler two large bells cast in bronze to mark the event. Ju Xiaoshi had these two auspicious objects carried in by twenty artists. Stroking his small beard,

he declared, not without pride: "Your Majesty, please be so kind as to have the indulgence to accept these two gifts that the humble servitor that I am has the honor of presenting you."

King Tang was astonished to see two enormous bells of an elegant and harmonious form, and being very pleased, he asked: "Would you explain to me what is inscribed around these bronzes?"

"As you command!"

And indeed, on each of the immense bells had been cast, equidistant from each other, four large inscriptions. The prime minister then plainly displayed his extreme diligence and his fertile imagination.

*Feng*

"This first inscription signifies 'abundance.' A vessel, placed on a solid base, is filled with grains. The word sings the exploits of Your Majesty in the administration of the country."

"Good! Excellent," murmured the king.

"This second sign represents a receptacle containing food, which is its very meaning. It signifies

that all of Your Majesty's subjects have food to eat, thanks to your clear-sightedness."

"And this third word?"

*Shi*

*An*

"It shows a harmonious household, serene and tranquil, inside of which a happy young woman is kneeling, her hands positioned with fervor on her breast, that is to say, on her heart, which beats with gratitude toward Your Majesty. Thus, this character signifies 'tranquility' and 'security.'"

Very satisfied with what he had just heard, the monarch was brimming with praise: "My prime minister is truly full of amazing ideas. And moreover, his creations show an incredible elegance. So, then, this fourth word, what does it mean?"

The high dignitaries who had come to celebrate the royal anniversary had, from the beginning, maintained a respectful silence.

"It means 'country,' 'territory,' 'state.'

*Bang*

As seen by the inventor of this new form, this sign depicts a sun shining on a river that, naturally, symbolizes the country; and on the left the plants are growing up to the sky. Permit me, Your Majesty, to tell you that you are this sun that provides light, food, and security to our kingdom."

The king burst out laughing. He was very happy with this last phrase, which summed up perfectly these four characters cast in bronze for all eternity.

Ju Xiaoshi, infinitely pleased with his invention, continued with eloquence: "Your Majesty, I respectfully request you to examine the four other characters inscribed on the second bell."

The king smiled at him. "I'm listening."

"This word is composed of two parts. On the left is a bow that our surveyors, under your orders, utilize to measure our lands, while on the right are seen two vast areas of land watered by a river.

*Jiang*

The whole represents our immense fertile royal territory."

The king stepped forward, shaking his head, and stopped in front of the second sign.

"This second word is composed of two parts: on the left there are two persons and on the right an eye over a heart. That signifies respect for the great benevolence and immense virtue of Your Majesty."

*De*

"My prime minister is truly very intelligent," exclaimed the king.

"The meaning of this third word is 'common,' because its upper part means 'everyone,' and its lower part is a mouth: everyone

*Tong*

speaks with the same mouth, that is to say that all your subjects sing your praises in unison,

Majesty. And finally, this last word resembles a man standing in a majestic posture whose head touches the sky. Thus it signifies 'the sky.'"

*Tian*

And as though he were more concerned to call attention to his inventions than to draw upon himself the favors of his royal master, the prime minister added: "The second series of four characters means that your territory and your virtue are as immense as the sky. Your exploits are thus engraved forever in our history!"

The same feeling of pride was to be seen on the faces of all present.

From that time on, such ideas multiplied, and the kings who followed had between five and six thousand inscriptions made on objects of bronze in order to provide a record of their high accomplishments, to commemorate events, to pray to heaven for good harvests, and to celebrate the memory of ancestors. Today, more than half of these pictographic signs of *Jinwen* have been deciphered and translated. It

should be noted that *Jinwen* remains a primitive system of writing, even though the form of its signs already prefigures the definitive mode of writing to come. Certain texts written in *Jinwen* during the Zhou dynasty (eleventh century to 770 B.C.E.) contain more than five hundred words.

And since, from the first dawn of time, Chinese monarchs have taken pleasure in viewing themselves as the sons of the heavenly dragon, and since their families constituted a social stratum of aristocrats who possessed the earth, the word "aristocracy" was written very large on the entry door to

*Gui*

their houses or on the wall that faced the threshold of the entry, taking the form of two hands holding a handful of earth.

*Gong*

For similar reasons, the shape of the word "respect" represented a man raising his arms to the sky toward a dragon.

The last king of the Shang dynasty invested a great deal in the production of bronze objects on which were inscribed longer and longer texts, surrounded by large characters imbued with specific significance.

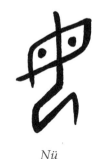

*Nü*

—*Nü* signified "revered woman showing her breasts (two small round points) to her baby."

—*Peng* represented a drum making its sound (three dashes). This

*Peng*

was an allusion to the drum hanging in front of the royal palace that the ministers had to strike three times in order to request an audience with the monarch. The original meaning of this word was "the sound of the drum."

Shells, which were considered precious objects and were used as money, were bound together in two bunches to form the word "friend."

*Peng*

*Pei* originally meant "blending the wine" for the king, who held a great number of banquets. By extension, it was interpreted to mean "to marry," "to blend," etc.

*Pei*

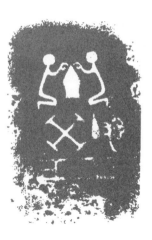

*Inscription on a bronze piece from the Shang dynasty*

*Shou*

A military advisor answering to the name of Guo Qiru was punished with death for daring to propose the form to designate "the head" or "the leader."

This form strongly resembled the head of an animal. King Zhou thought it was an insult referring to him and had this mandarin put to death on the occasion of a ceremony devoted to the memory of the royal ancestors. In this way, the word "corpse" came into being, resembling a man sitting in profile on an altar.

*Shi*

It should be noted that very few Chinese today know *Jinwen*, which is viewed as a set of decorative objects by certain literary snobs or refined persons desiring to bring a touch of elegance to their living rooms. For this reason certain calligraphers have become specialized in this form of writing so that they can produce calligraphies that will be sold, often at exorbitant prices, to a clientele composed mainly of nouveau riches and celebrities.

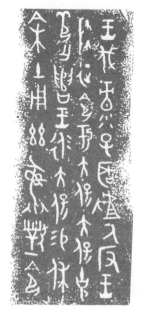

*A short text cast in the Daboding bronze*

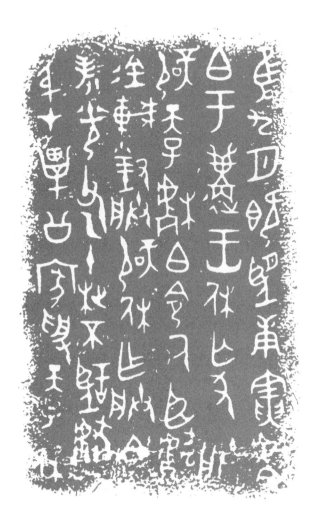

*A text in* Jinwen *molded in relief on a piece of bronze*

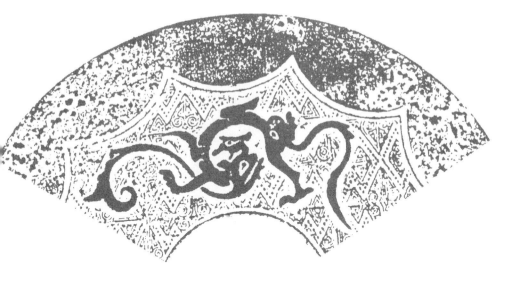

*The character "dragon" on a bronze mirror from the Warring States Period*

*The character "phoenix" on a bronze mirror from the Warring States Period*

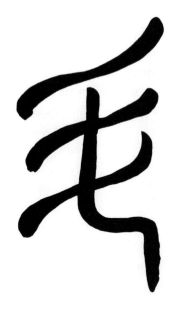

# 4 SMALL SEAL SCRIPT
## SCRIPT
### *Xiaozhuan*

Q IN SHIHUANGDI (the first Chinese emperor) overcame a great number of independent kingdoms and, in 222 B.C.E., founded his great dynasty, the Qin, the first central power to control the whole extent of ancient China as an undivided entity. Wishing to attain eternal life and eternal power, he sent people to search the high mountains and isolated islands for medicinal plants that could be used, in the form of elixirs, to prolong life. At the same time, in order to prepare and perpetuate his power over this huge empire, he decided to unify the many forms of writing then in use in the ancient kingdoms. He entrusted this task to his palace minister, the scholar Zhao Yunshao, who was a specialist in this field, and particularly in *Jiaguwen* and *Jinwen*. Qin Shihuangdi ordered him to unify these different styles of writing, to compare them and to simplify them with a view toward producing a writing style that would be accessible to the entirety of the populace.

Zhao Yunshao, a poet and calligrapher in the *Jinwen* style, drew inspiration from the ancient modes of writing, especially *Dazhuan*, which was in official use in the kingdom of Qin, to create a new standardized form known as *Xiaozhuan*, which is distinguished by its elegance, simplicity, ease of construction, and form.

But Zhao Yunshao was also well known for his pride and cruelty. He only too happily assisted the emperor in burying alive intellectuals who were opposed to the regime and in burning books that used other forms of writing, with the sole purpose of rapidly establishing the use of *Xioazhuan*

*Shisong Gui*, Xiaozhuan *inscription from the Qin dynasty that sings the praises of the king*

and thus achieving a uniform writing style throughout the empire.

The first character in the *Xioazhuan* style that he proposed to the emperor was, of course, Qin, the very name of the dynasty. Zhao Yunshao had studied and compared the *Jiaguwen* form of this word and its *Jinwen* form.

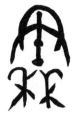

*Jiaguwen*          *Jinwen*

He found these two signs complicated and difficult to draw, because, as pictograms, they were too erratic in the directions as well as the size of the lines composing them to be imitated by the population. So he simply transformed them into straight or curved lines. Thus, the form of *Xiaozhuan* was conceived and created.

*Qin*
*Xiaozhuan*

Qin was originally a principality in China on the banks of the Yellow River, in the center of the present-day province of Shaanxi, one of the cradles of Chinese civi-

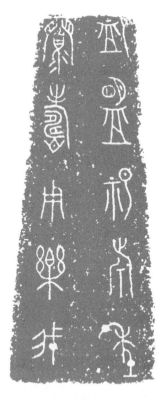

*Part of the inscription cast in bronze on a bell called the Zhugongtuo Zhong*

lization—a great producer of rice, wheat, and millet. The word *Qin* was invented in the form of a drawing of two hands holding a flail for threshing cereal grains.

Qin Shihuangdi opted to place his capital at Xianyang, a large fortress town at the heart of his province. On the north bank of the Yellow River, he had constructed the immense imperial palace of Efanggong. On the two door panels of the grandiose portal, the large character *Qin* was written with gold powder on a red background. This signified that the country was flourishing.

One of the great concerns of the monarch Shihuangdi was the continual troubles caused by the nomadic tribes in the regions of the northern border. One day, he took counsel with his favorite minister Zhao Yunshao, who advised him to raise a long, high wall, winding across the mountain chains in the north of the empire. The monarch approved this idea, and tens of thousands of workers were put to work constructing it.

Zhao Yunshao called this titanic labor *Chang Cheng* (Great Wall) and wrote these two words in *Xiaozhuan* on the door of the first observation tower in the wall.

*Chang*          *Cheng*

Another historic accomplishment of Qin Shihuangdi was to exercise a major influence over the development of the Empire of the Middle—that of unifying the many weights and measures that then existed. Zhao Yunshao helped him in this task by standardizing the characters corresponding to the weights and measures.

## WEIGHTS AND MEASURES

The first example is a kind of stone axe serving as a unit of weight of about half a kilogram.

*Jin*

Second example: This is a branch being used as shoulder yoke for carrying a large sack filled with cereal grains. This character represented a unit of weight of about fifty kilograms.

*Dan*

Third example:

*Dou*

In *Jiaguwen* and *Jinwen*, this character *Dou* represented a ladle.

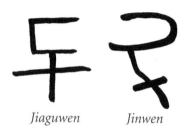

*Jiaguwen*          *Jinwen*

## NUMBERS

The first example is *Shi*:

*Shi*

In ancient times, all the numbers were indicated by stalks of grass or twigs of wood. When they were arranged horizontally, they indicated units. If a vertical line was added to a horizontal one, that represented the number ten. In fact, from the very dawn of time, the Chinese utilized a decimal system.

Second example: A person standing with a pole at his waist at

*Qian*

that time signified "a thousand," while the scorpion was used to signify "ten thousand." Perhaps the meaning here was that that number was as complicated as the feet of a scorpion.

*Wan*

## MEANS OF TRANSPORT

In the first example, this word, which evokes rather clearly the silhouette of a horse with its mane blowing and rearing on its two hind legs, did, in fact, signify "horse."

*Ma*

Second example: This character, representing a chariot, appears

to be quite simplified in comparison with those of the preceding period. The three wheels are now replaced by a single central one.

*She*

Third example: *Zhou* is a small boat. In the *Xiaozhuan*, this character is still rather pictographic. It represents a dinghy in the form of a crescent with one end pointed and raised and showing the cross braces inside. This was very frequently used as a means of transport,

*Zhou*

and *Zhou* very quickly became a

radical serving to form other words connected with navigation.

## CEREMONIAL PROTOCOLS

First example: This word signifies "guest." It is composed of a man received as a guest at a house, and a shell representing the precious gift he intends to offer.

*Bin*

Second example: A man standing on the earth, whose two arms are slightly lifted to the sides and whose legs are ceremoniously separated—a position that was required at the time when listening to the emperor or when receiving a guest with the greatest level of respect.

*Li*

Third example: The word *Wu* in *Jiaguwen* was represented by a man dancing with a bullock's tail in each hand. In the *Xiaozhuan* version, we see clearly the two feet in the lower part of this character and the two hairy tails on the two sides of the

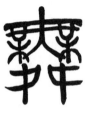

*Wu*

dancer's body, beneath a horizontal line on top. This dance was frequently performed in the imperial palace and in the houses of the great aristocratic families on the occasion of receiving guests.

## SACRIFICIAL RITES

It must be noted that during this period Confucianism was accorded a place of major importance by the aristocrats, and rites were one of the main pillars of the Confucian way. That is why we find a great deal of descriptive material in the ancient texts regarding sacrificial rites.

First example: This character represented a three-legged altar on which, on the left side, a piece of animal meat had been placed and was being held by a hand on the right side.

*Ji*

Its meaning was "to present a sacrifice to the spirits or the ancestors."

Second example: A kitchen utensil of the period, on the left, with a hung dog on the right. The meaning of this was to cook a dog in a

*Xian*

vessel in order to offer it on an altar dedicated to the ancestors.

## THE CARDINAL DIRECTIONS

Qin Shihuangdi undertook a major effort to record the topographical features of his vast empire. His engineers had only a very vague definition of the different directional orientations. Zhao Yunshao wiped the slate clean of the confusion prevailing in this area and provided precise indications regarding the cardinal directions. This accelerated the development of Chinese geomancy *(Feng shui)*, which, oddly enough, became an object of sincere veneration on the part of Americans and Europeans as the twentieth century drew to a close.

A sack filled with cereal grains and knotted at the top and bottom with two cords represented the east.

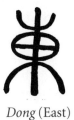

*Dong* (East)

A musical instrument very common during the period of the Warring States and up until the Qin

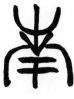

*Nan* (South)

dynasty took the form of a bronze bell suspended from a knob. This instrument signified the south because of the sound, *nan*, that it produced.

Earlier, in *Jiaguwen* and *Jinwen*, a single round nest already represented "west." But the first Chinese emperor, Qin Shihuangdi, finding this lacking in joy, or too austere, gave the order to add a bird to it to signify a bird returning to its nest at the time when the sun goes down in the west. Thus, this sign became the symbol for this cardinal direction.

*Xi* (West)

*Jiaguwen*      *Jinwen*      *Xiaozhuan*

We have already discussed the next character: two men standing back to back, forming the word "north," which had and continues to have the same pronunciation as the word meaning "back to back."

*Bei* (North)

# AGRICULTURE

In the first example, the word *Mi* means "a grain of rice." Originally, this character was written with six grains scattered all around a horizontal line, representing the space between cultivated terraces. During standardization, Zhao Yunshao put a cross in the middle to separate four equidistantly placed grains originating from the four cardinal directions. This signified that all areas of the empire produced cereals abundantly.

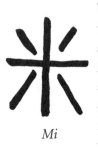

*Mi*

Second example: Chinese archeologists have shown that in ancient times in the north of China, our ancestors grew a great deal of millet, the ears of which are heavy and loose, spilling and scattering their grains all around the fields. The character for millet, *Shu*, looks like this plant with two ears bending to either side; but in addition, in the lower part of the character, lines signifying water were added. However, according to some scholars, the lines below the stem do not represent water but reflect

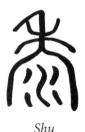

*Shu*

the fact that millet could be used to make the wine that the inhabitants of the north drank frequently to combat the cold. It is a fact that to this day, the northern Chinese adore the alcoholic beverage they distill from millet.

# DOMESTIC ANIMALS

First example: We can see clearly that we are dealing here with a pictographic character, because the form of the character clearly resembles a rabbit, with two long ears curving down a little bit over its raised head. It is standing up on two small legs.

*Tu*

Second example: This is a goat's head seen head-on. We can clearly make out the two horns, curving slightly downward; the first horizontal line represents the two eyes and the second represents the nose with a pointed muzzle.

*Yang*

Third example: Originally, this word meant "pig." In the *Jiaguwen* system, it did clearly look like a pig that had its head lifted toward the sky and its tail hanging toward

the ground. In the *Xiaozhuan*, a horizontal line replaced the raised head, and the slightly curved back as well as the four legs and

*Shi*

a short tail added to the back are preserved.

Today, this word no longer exists except in certain expressions. In the common language, it is replaced by another character, *Zhu*.

Fourth example: Like the character *Yang*, this is a pictographic word that evokes the head of a bullock whose two horns are raised toward the sky, while

*Niu*

those of the goat curve downward.

Qin Shihuangdi is venerated by the Chinese as a great man of politics. He could take pride in being the father of *Xiaozhuan*, which is still used today as the basis for modern Chinese writing. People like very much to decorate their reception rooms or cultural meeting places with *Xiaozhuan*.

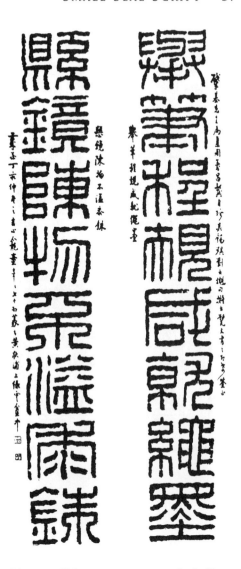

*Two parallel sentences on stretched silk*

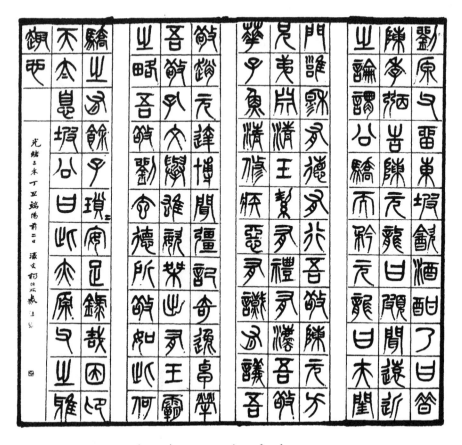

*A precious text written by the great calligrapher Yang Yisun of the Qing dynasty. The highly significant contribution to Chinese civilization of the first Chinese emperor Qui Shihuangdi, who is sometimes glorified and sometimes cursed, remains forever engraved on all memories thanks to one of his greatest achievements: the Great Wall of China.*

# 5 CLERICAL SCRIPT
*Lishu*

AS WE CAN SEE, *Xiaozhuan*, though graceful and esthetically harmonious, was complicated and difficult to write, and this was a great handicap for its spread among the people. A tendency to simplify it and make access to it easier began at the end of the Qin dynasty. This was continued, if not further emphasized, by the successive emperors of the Han dynasty (206 B.C.E.–220 C.E.). In the West, the Han are called "the Chinese."

One day, Liu Bang, emperor and founder of the Han dynasty, read a proposal composed by his minister of justice of which he was able to understand very little. This was because this former leader of a peasant revolution who was partially illiterate did not know *Xiaozhuan*, which was reserved at this time for the highest classes of society. He summoned Wang Qikun: "I am only able to read your proposal with difficulty," he told him. "It is absolutely necessary to reform this style of writing to make it easier to write and to read."

Wang Qikun, who was a great calligrapher, was all the more in agreement with His Majesty the Emperor because the earlier styles of writing, *Jinwen* and *Xiaozhuan*, hindered him in giving free rein to his calligraphic creativity.

A few days after this interview, he invited a hundred calligraphers who were known in the capital to come to a meeting in a large Taoist monastery. After a sumptuous meal, he had a set of the instruments and materials needed for writing brought to each participant—a brush, silk cloth, ink stick, and ink stone. Then he made the following announcement:

"My respected and honored friends, know that this banquet was not organized by me but is being offered to you by His Majesty, our great emperor. Would you now be so kind as to render me a service . . ."

Everybody kept a solemn silence and waited to hear the rest, wondering what sort of a service might be involved.

The minister continued: "I would like you to exercise your calligraphic art on the spot, as quickly and as freely as possible."

The guests looked at each other without really understanding what was expected of them. But in the presence of such a high functionary of the imperial court, who

dared to disobey? So they all set to work. Some of them sought to elucidate the goal of this "service" and assiduously wrote that they were afraid to commit the least imprudence that might lead to their being punished by the emperor. Others, pedants who were attached to the ancient forms of writing of *Jinwen* and *Xiaozhuan*, did their calligraphies in the most orthodox possible form. Still others, somewhat intoxicated by the good wine from the imperial cellars and carried away by their habitual scorn for all conventions, took advantage of this unexpected opportunity they had been given to challenge the official forms of writing with imagination and even insolence.

At the end of the session, the minister collected all the copies and thanked their authors.

A month later, Wang Qikun called together the calligraphers who had been the most free in their responses and had let themselves be borne along by their intoxication with calligraphy. He congratulated them: "His Majesty the Emperor has granted me the honor of informing you that you have done good work. He very much appreciated that your calligraphy did not confine itself to the ancient stereotyped forms.

Personally, I am infinitely grateful to you. Thank you for your efforts, which have greatly helped me in my mission of reforming the ancient forms of writing that are too difficult for our peasants. Your calligraphies have filled me with precious inspiration and have served me as examples."

The following day, Wang Qikun presented to Liu Bang his list of the first characters to be reformed.

"Majesty, with your permission, I have the honor of showing you some simplified words in my style, which I call *Lishu*." The emperor hastened to unroll the silk fabric on which his minister had already written a hundred calligraphic characters of *Lishu*, much more readable and recognizable than anything in *Jinwen* and *Xiaozhuan*.

"Show me, dear minister, how to write these signs that are so magnificent," the monarch commanded.

Wang Qikun complied at once and set to work at the desk of the emperor, where the necessaries for calligraphy had already been set out. To make the difference between the two styles very clear, each character was written in the *Xiaozhuan* form and then in the *Lishu*:

*Xiazhuan*          *Lishu*

*Lu*

This character, which is pronounced *Lu*, means "the foot of the mountain." Liu Bang understood why his minister had presented this character to him first. It had been at the foot of the famous Mount Phoenix that he had chosen to launch the peasant revolution that had carried him to the throne.

The word *Xin*, which means "new," carried the implication that under the emperor Liu Bang, the

*Xiazhuan*          *Lishu*

*Xin*

Chinese were going to reform their lives, living happily as they worked with boundless enthusiasm to build a new society.

*Yu* means "the fish." Since the dawn of time, the Chinese have never missed celebrating the eve of the new year with a large platter of fish, because this character has a homonym that means "in excess" or "surplus." On the occasion of this feast, the Chinese like to have the year that has just passed symbolically summed up as a favorable one.

*Xiazhuan*          *Lishu*

*Yu*

The word *Pu* means "valet." The minister of justice, Wang Qikun, explained that from that time forth all the inhabitants of the empire were the faithful subjects of His Majesty and that he was His Majesty's valet, devoted body and soul to his service. Liu Bang devoted his attention to admiring the calligraphy without paying too much heed to the flattering remarks of his minister.

*Xiazhuan*          *Lishu*

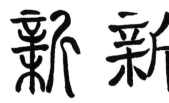

*Pu*

*Xiazhuan          Lishu*

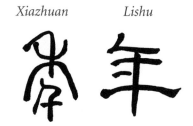

*Nian*

Nian, "year," had its origin in the word "harvest," for in the *Jiaguwen*, it was written in a form that evoked a man returning home after his day of work, carrying his harvest, a bale of rice, on his back.

*Jiaguwen*

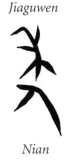

*Nian*

The emperor Liu Bang failed to understand why his minister pre-

*Xiazhuan          Lishu*

*Lei*

sented him this character, which meant "thunder." Without waiting, Wang Qikun explained: "Your Majesty certainly recalls the decisive battle that made it possible to enter the former imperial capital and establish his throne.

This battle took place in a valley known as "thunder of heaven."

A big smile lit up the emperor's face. After having taken tea, Liu Bang, literally dazzled by his minister's erudition, or rather by this beautiful writing, so clear and regular, which he had appreciated from the moment he had set eyes on it, asked: "Could you write for me the words *Fu* and *Lu*?"

"At your command!"

*Xiazhuan              Lishu*

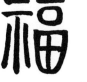

*Fu*

*Lu*

*Fu* means "happiness." All Chinese like to paste a large rendering of the character *Fu* on their entry door, written in calligraphy on red paper. This means "happiness is coming." The character *Lu*, on the other hand, means "the remuneration of a functionary."

The two terms combined seem to express a wish on the part of the emperor: "I would like all my

subjects to live in happiness and all my mandarins to be generously remunerated."

Then the emperor, truly deeply moved, exclaimed: "Another word—dragon!"

In the Chinese tradition, the dragon has always been the symbol of supreme power and of the highest level of dignity, embodied by the emperor. Wang Qikun immediately understood that his sovereign considered himself the reincarnation of the celebrated and sacred dragon. For that reason, it was with fervor that he wrote this word:

*Xiaozhuan*          *Lishu*

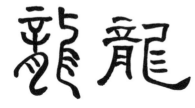

*Long*

And the calligrapher added four other words, which could only flatter the ambition of his all-powerful interlocutor.

The two first characters, *Huang* and *Di*, figured in the title of supreme power that the first Chinese emperor, Qin Shihuangdi, had begun to use. It means "the emperor," and the last two words

mean "ten thousand years." These four characters combined mean "Long live the emperor!" We have already mentioned that this first Chinese emperor sent out thousands of people trained in pharmacy to search for medicinal

*Xiazhuan*          *Lishu*

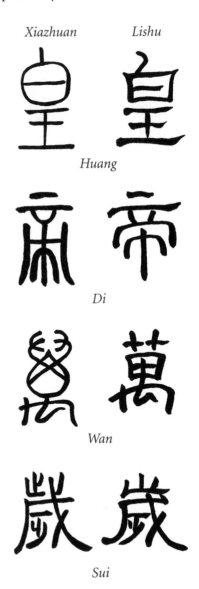

*Huang*

*Di*

*Wan*

*Sui*

plants that could serve in the concoction of miraculous pills capable of assuring him eternal life. He declared one day: "I shall live ten thousand years."

From that time forward, dignitaries called their emperor "Ten Thousand Years," and this title remained current until the emperor Puyi, the last Chinese emperor of the last Chinese dynasty, the Qing, was driven from his throne in 1909.

History sometimes likes to surprise us. Fifty years after the departure of Puyi from the imperial palace in Peking, the new red emperor, the greatest dictator in Chinese history, Mao Zedong, reassumed this feudal title and cries of "Long live President Mao! May he live ten thousand years!" resounded throughout the four corners of China from dawn to midnight for more than ten years.

Liu Bang, enthusiastic and satisfied, commanded his minister of justice to top off his functions with that of Advisor on Calligraphy to the Imperial Palace and asked him to decorate all the pavilions of his palace with his *Lishu* calligraphies.

Wang Qikun successfully completed this new mission, which he began by writing, in gold powder on a lacquered panel that hung on the wall behind the imperial

throne, the two following characters, which mean "sincerity."

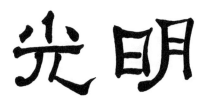

*Guang*          *Ming*

After that, he drew two others that meant "honesty" or "uprightness" in the audience chamber of the imperial compound:

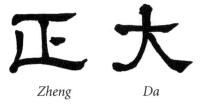

*Zheng*          *Da*

The empress appreciated this new form of writing. After giving birth, following the traditional custom, she placed a jade amulet around her son's neck. One day, it occurred to her to summon the advisor on calligraphy to the imperial palace to ask him what he might be able to do for the occasion of the hundred-day anniversary of the newborn. The intelligent advisor did not hesitate for an instant before suggesting to her that he inscribe a few words on the jade amulet. The empress thought this was an excellent idea. Wang Qikun therefore inscribed

on the front of the amulet the two following words:

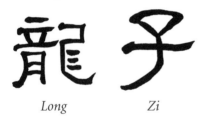

Long                Zi

which meant "son of the dragon," because all the emperors considered themselves the sons of heaven and saw their children as descendents of the celestial dragon. This also explains why the emperors all wore *Longpao* (robes embroidered with dragons).

On the other side of the jade amulet, the calligraphic advisor carved two other words, meaning "precious life":

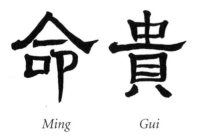

Ming                Gui

We can easily understand the significance of these four characters: "The son of the dragon has a precious life."

Wang Qikun could hardly wait for this idea of his, which had thus far been put into practice only in particular circumstances, to become a real custom. And in fact, still today, newborn Chinese, even if they are not "sons of the dragon," wear around their necks and wrists a piece of jade or a gold medal on which are still inscribed four words that are a sign of the concern of all parents for the good health of their children.

The empress wished for her son to be reared in the traditional culture and counted on her minister of justice to provide her with further advice. The minister said nothing, but instead once again presented to her four new characters, this time inscribed on four plaques:

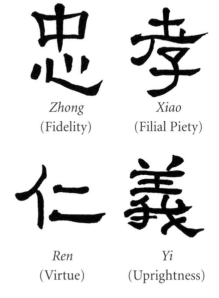

Zhong                Xiao
(Fidelity)        (Filial Piety)

Ren                Yi
(Virtue)        (Uprightness)

The empress recognized these four characters as embodying the

quintessence of the teachings of the sage Confucius, for whom she bore a profound respect. She had these four plaques hung in the baby's chamber. But according to the historical documents, when a huge fire broke out in the imperial palace, these plaques were reduced to ashes.

Wang Qikun worked for a period of twenty years to transform the words of the *Xiaozhuan* style into *Lishu*, not without encountering fierce opposition from the conservatives.

Liu Che, the sixth emperor of the Han dynasty, even had one of his ministers, who had been carrying on an all-out campaign against this reform, attempting to maintain *Xiaozhuan* and *Jinwen* at all costs, guillotined along with his consort.

But the current of history was favorable to *Lishu*, which corresponded to a desire on the part of the people for writing to be simplified and made easier to learn. Specialists are of the opinion that *Lishu* represents an important turning point in the evolution of Chinese characters, marking the passage from the primitive phase to the modern phase.

*Lishu* is in common use today in China, Taiwan, Hong Kong, and in all the Chinese communities spread throughout the world, because while it is easy to learn, it also is not lacking in beauty and elegance. Let us look at a few more examples:

*Dry style, full of grace*

*Broken and vigorous style*

重親致歡曹景　完易世載德不　隕其名及其兹　政清擬夷齊宣

*A model that beginners like to imitate*

# 6 STANDARD SCRIPT
## SCRIPT
*Kaishu*

Around 200 C.E., the end of the Han dynasty, thanks to advances in agriculture and artisanal production, the Chinese made a true cultural leap forward. As part of this, writing gradually became free of its elitist restraints and began to undergo a process of democratization. Little by little it became integrated into the world of commerce and agriculture. However, *Lishu* was still considered too elaborate, because its curved and oblique lines were too difficult to reproduce.

Liu Xie, the last emperor of the Western Han dynasty, published an imperial decree commanding the people henceforth to utilize a new form of writing, called *Kaishu*. The name had its root in the word *Kai*, meaning "model to be imitated"; thus *Kaishu* means "writing model to be imitated."

This writing is more regular and better adapted to Chinese brushes, because its horizontal and vertical lines make it easier for children and people who are not highly educated to learn. This simplicity explains why, today, the Chinese still write and read *Kaishu*.

In this decree, the emperor established a list of common reformed characters, starting, of course, with the word *Han*, which was at the same time the name of the dynasty and of the Chinese nation. From that time on, this word was written thus:

*Han (Kaishu)*

instead of:

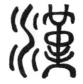 

*Han*
*(Xiaozhuan)*

*Han*
*(Lishu)*

From that time on, the word *Han* became the official name for the Chinese. Next, the emperor enumerated the basic words that would enter into the composition of other words. Let us look at a few examples:

*Ri (Kaishu)*

(1) The word *Ri*, which means "sun" or "day."

*Ri (Xiaozhuan)*          *Ri (Lishu)*

(2) The word *Yue*, which means "the moon."

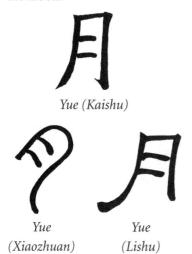

*Yue (Kaishu)*

*Yue*
*(Xiaozhuan)*

*Yue*
*(Lishu)*

(3) The word *Shang*. In this character, all the elements are located above a horizontal line, which

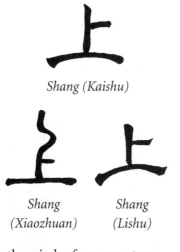

*Shang (Kaishu)*

*Shang*
*(Xiaozhuan)*

*Shang*
*(Lishu)*

in the minds of our ancestors stood for the horizon. It is equivalent to the expression "above" or "at the top."

(4) The word *Xia*.

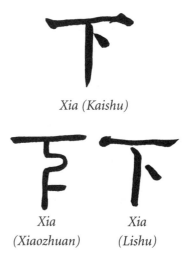

*Xia (Kaishu)*

*Xia*
*(Xiaozhuan)*

*Xia*
*(Lishu)*

This is the contrary of the previous character. All the elements are located below a horizontal line. It means "below" or "at the bottom."

(5) The word *Da*.

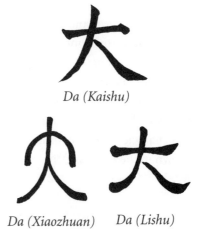

*Da (Kaishu)*

*Da (Xiaozhuan)*    *Da (Lishu)*

In *Xiaozhuan*, its form represents a man standing, vigorously

spreading out his arms. In ancient times, it was thought that man dominated the world through his size. This character had the original meaning of "largeness" or "size."

(6) The word *Xiao*.

*Xiao (Kaishu)*

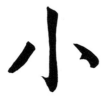

*Xiao*
*(Xiaozhuan)*　　*Xiao*
　　　　　　　*(Lishu)*

In the *Jiaguwen* and *Jinwen*, three small vertical lines represented three grains of sand, meaning "small." From *Xiaozhuan* on, the middle line was elongated and the two others became shorter; this character took the forms shown in the *Lishu* and the *Kaishu*.

The emperor's list was rather long. It included all the words in common use, or nearly that. Liu Xie was right to start out with simple and common words, because using them, one can easily compose many other characters.

Thus, using the word "sun," more than two hundred new words were invented. For example:

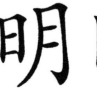

*Ming* (Clear)　　*Nuan* (Mild, lukewarm)

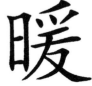

*Mu*
(Twilight)　　*An*
(Dark)

In the same way, starting with the word "moon," three hundred other words were composed, of which the majority have nothing to do with the moon or its light:

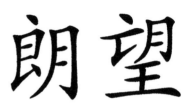

*Lang*
(Clear)　　*Wang*
(To look)

脱 朝 尖 美

*Tuo*
(To take away)

*Zhao*
(Morning)

*Jian*
(Pointed)

*Mei* (Beautiful,
pretty)

肺 服

*Fei*
(Lung)

*Fu*
(Clothing)

Using the word "small," twenty
words can be composed. For
example:

劣 光

Using the word "large," one can
obtain more than fifty compound
derivatives; for example:

*Lie* (Bad)

*Guang* (Light)

太 奔

少 堂

*Tai*
(Too much)

*Ben*
(To run)

*Shao*
(A little)

*Tang*
(Room)

央 奋

雀 省

*Yang*
(Middle)

*Fen*
(Make an effort)

*Que*
(Sparrow)

*Sheng*
(Economical,
province)

During the thirty years of his reign, the emperor Liu Xie had printed on all his decrees and all his other documents, the title of his throne, *Xiandi.*

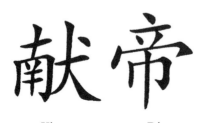

Xian            Di
(To offer)      (Emperor)

History does not tell us specifically whether this emperor was a linguist and a calligrapher. Whether or not he was, he surrounded himself with a score of experts in this field, and this had major implications for the reform of the structure of Chinese characters. Following their research, these experts established that Chinese characters exhibited the following eight kinds of basic lines:

1. Horizontal line

2. Vertical line

3. Line curving to the left

4. Line curving to the right

5. Point

6. Hook

7. Line rising to the right

8. Broken line

But with these eight basic lines, all the characters could not be formed. These experts, therefore, with the approval of their monarch, set forth nine additional compound lines to be allowed:

6. The horizontal + the broken line + the vertical + the hook

1. The horizontal + the curve to the left

7. The horizontal + the curved broken line + the curved horizontal + the hook upward

2. The horizontal + the broken line + the curve to the left

8. The curve to the left + the horizontal + the line broken toward the left + the hook

3. The horizontal + the broken line + the line rising to the right

9. The horizontal + the curve to the left + the curved vertical + the hook

4. The vertical + the horizontal + the hook upward

The emperor even went so far as to publish a manual of model writing so that all of society could write in the same way and in the same style.

Here, on the following pages, are some examples from it:

5. The horizontal + the hook

This emperor provided posterity with a practical form of writing from which contemporary Chinese people are still benefiting.

Thus, their daily writing dates from more than 1700 years ago. The fact alone that it has lasted so long shows the value of *Kaishu.*

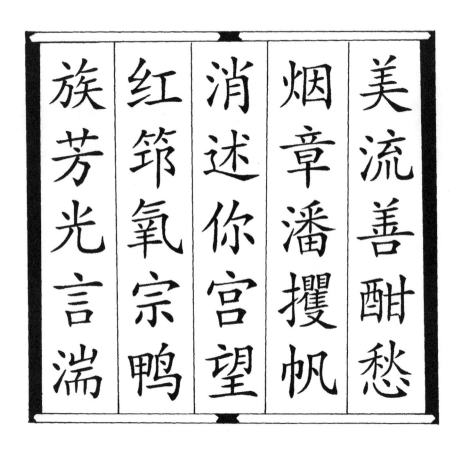

能 禮 手 上
武 弘 登 妙
之 象 飛 冰
悲 念 感 遷

*The regular style of Yan Zhenqin, one of the greatest masters of calligraphy of the Tang dynasty*

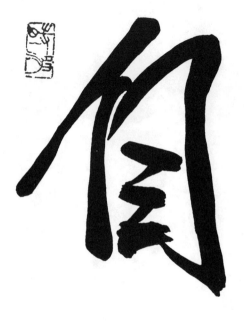

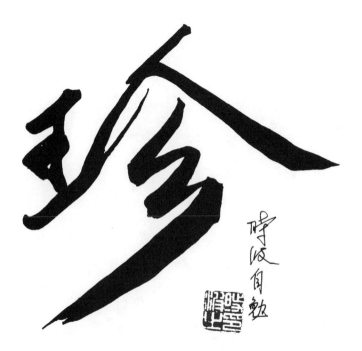

*Free* Kaishu *("self-esteem")*

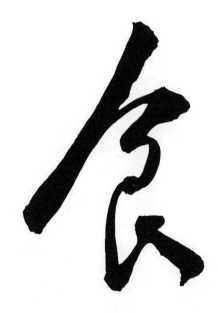

# 7 CURSIVE SCRIPT
## *Caoshu*

$S$ TARTING WITH *Jiaguwen* and continuing with *Kaishu, Jinwen, Xiaozhuan,* and *Lishu,* Chinese writing was practiced within a strict framework, governed by restrictive rules, all or almost all set forth and imposed by the supreme power.

In contrast, *Caoshu* observes no rules. It even goes beyond not observing rules to complete freedom, which was a rare thing in the ancient, centralized empire, so subject to heavy codes of uniformity.

Contrary to what is generally supposed, *Caoshu* is not the product of modern society. It made its appearance between the end of the Qin dynasty and the beginning of the Han dynasty—in other words, about 200 C.E. During this period of considerable social troubles, the intellectuals—prey like the rest of the population to wars and natural calamities—put forth a fresh challenge to the system of traditional thought, thus provoking a major cultural ferment.

It was within this context of general instability that the figure of Zhou Yuguang appeared. This calligrapher of the Han dynasty had no resources besides his beautiful writing. He bartered his calligraphy in the market for a little bit of grain to feed himself and a little bit of wood for heat. To vent his bitterness, he refused to respect the rules of *Xiaozhuan* and wrote in a cursive fashion just as he saw fit. As though spellbound, people fought for these calligraphies that were devoid of rigor or constraint, and the literati began to take them as models to follow. Thus, *Caoshu* spread like an oil spot and is still in use today.

Following this cursive form, each calligrapher creates his own style, more or less observing the forms of *Kaishu.* Though he was the pioneer of *Caoshu,* Zhou Yuguang nevertheless did not dare to go too far, and his writing in the *Kaishu* form remained the basis of his new form.

*Caoshu* means "grass writing" in Chinese, which clearly evokes this style based on rapidly drawn strokes done very much at the urging of the author's moods and feelings. One of the specific qualities of *Caoshu* is that its characters are drawn in continuous strokes without abrupt hitches or breaks. Thus, they are difficult to decipher. Let us look at a few examples:

*Caoshu*   *Kaishu*

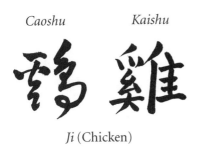

*Ji* (Chicken)

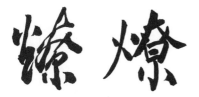

*Liao* (To kiss)

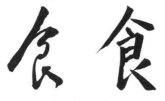

*Shi* (Food)

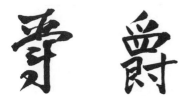

*Jue* (Nobility)

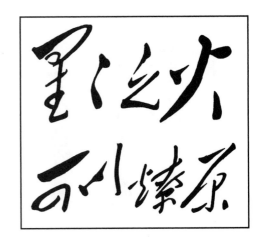

1. Seeking Elegance

The fluid and elegant writing style shown here remains legible. The author wishes to manifest here the amplitude of his soul, which, as the text shown above says, is a spark that can encompass the world like a prairie fire.

The Chinese calligraphers call *Caoshu* "writing at the urging of the will" or "writing that listens to one's mood." This means that this form of writing reflects a mood, a feeling, or a desire.

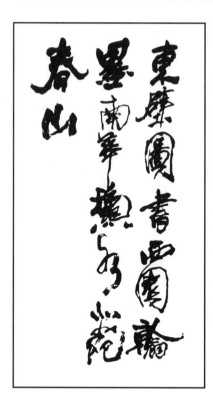

2. Putting the Emphasis on Vigor

This calligraphy, the work of a great master of the Ming dynasty, is characterized both by freedom of brush movement and by the force in the wrist that holds the brush. The calligrapher began and ended almost every one of his strokes with a hard push on the brush. This work, taken as a whole, gives the impression of vigor, strength, and elegance.

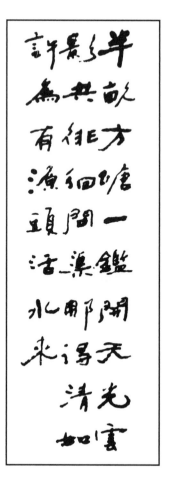

3. Seeking Harmony

The author of this piece—a famous calligrapher of the Ming dynasty—was also a well-known poet. He traveled a great deal in the mountains, seeking there the harmony of nature, which he attempted to convey in his many poems as well as in his *Caoshu* calligraphy.

The strokes of his brush flowed into each other in a natural manner.

They were refined, elegant, sometimes resembling many snakes freely gliding—but in a certain order—along mountain paths; sometimes resembling notes of music similar to the murmur of a brook playing drunkenly in the springtime sun over pebbles of many colors, passing among luxuriant grasses.

4. Manifesting a Sublime Emotion by Means of Irregular Strokes

The work of *Caoshu*, whose author was Zheng Xie (Banqiao; 1693–1765), expresses well the scorn for the high functions of the imperial court and the aspiration for personal freedom of this calligrapher who had been cast from favor and who lived out the twilight years of his life as a hermit. We note that the strokes are powerful and heavy in some places and in others, fine and fluid.

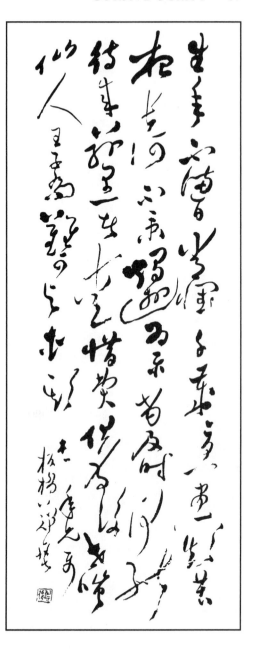

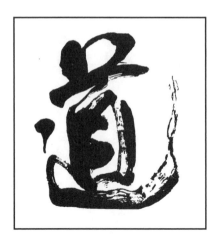

In the two following characters—which mean "the fragrance of ink"—the author attempts to convey the impression of exhalations of fragrance being wafted from his dry, flying strokes.

5. Expressing a Movement

The character (shown above), *Dao* (way, moral code), is beautifully drawn: the black and dry strokes combine well to express the elegance of the form and the profundity of the meaning.

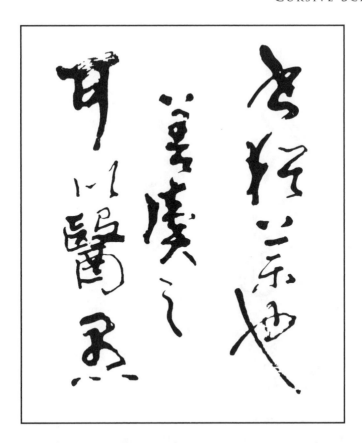

6. Manifesting Madness, Passion, Insolence, etc.

This type of *Caoshu*, still very much in vogue today, varies with its authors, who invent a large number of words that are illegible but are very esthetically executed and, thus, appreciated by collectors. This type of calligraphy is often called *Kuangcao*, "crazy calligraphy."

Here are two other very elegant examples of *Caoshu*:

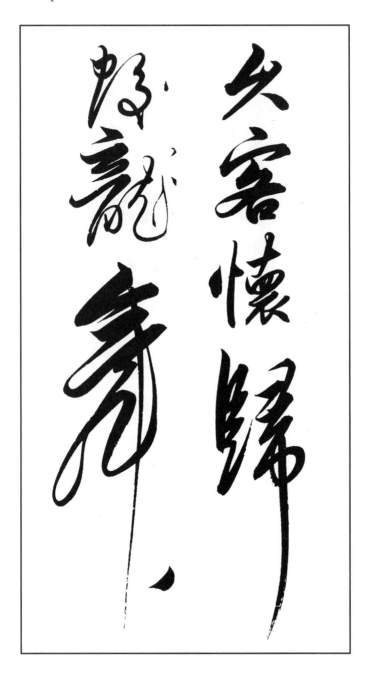

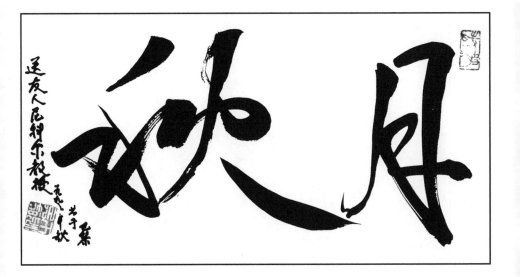

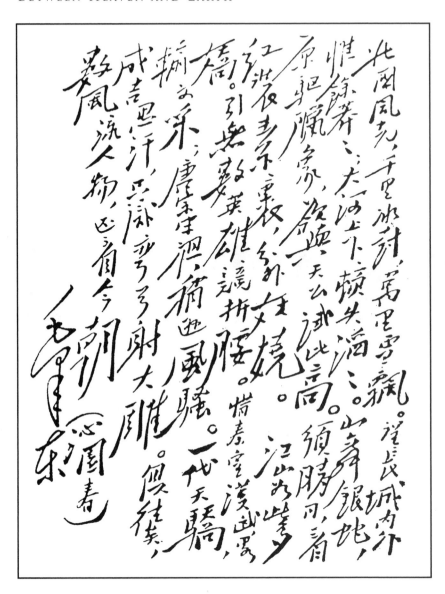

7. Manifesting an Inflexible Will

Written by Mao Zedong in 1936, right in the middle of the war against the Japanese, this calligraphy is considered in China a masterpiece of *Caoshu* of the contemporary period. In a style that continues with consistency from beginning to end, it exhibits amplitude of spirit, nobility of soul, and inflexibility of will. Mao is recognized as one of the best calligraphers of the contemporary period.

8. Manifesting Beauty through
Clumsy Strokes

Certain calligraphers find beauty
in clumsiness, which is expressed
in childlike strokes, either by in-
tentional asymmetrical construc-
tion of the words or by dispropor-
tion in the size of the strokes rela-
tive to each other. This is called
"esthetic clumsiness," of which an
excellent example is given below.

9. Expressing a Particular Aspiration through an Esthetic Arrangement of Words

The example given above is composed of four characters meaning "developing the Chinese nation." But at first glance, the composition looks more like an abstract painting than a political slogan.

10. Seeking the pinnacle of the harmony between heaven and earth

There is no one in China who does not know the name of Wang Xizhi. He is the greatest calligrapher in all of Chinese history. Wang Xizhi (303–361) lived under the Eastern Jin dynasty. He devoted all of his time to imitating the past masters of calligraphy before forging his own style of *Caoshu*. He was unanimously glorified as "the god of calligraphy."

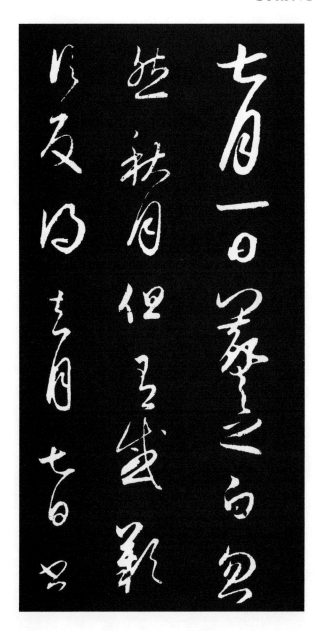

Here is a page that is supposed to express his impression of autumn. Elegant, the fine and graceful lines flow on in one character after the other with an effect like clouds dotting a serene sky, like limpid waters rushing noiselessly, like a gentle wind caressing the rustling leaves of a tree. Through this, Wang Xizhi sought to express the

highest level of the harmony that reigns in nature, between heaven and earth.

*Caoshu* has many different schools devoted to it, each differing in style from the others. Each school trains masters of the first order, with the result that Chinese calligraphy continues to advance. *Caoshu* was highly appreciated by the ancient calligraphers, as well as the modern ones, because the fluid continuity of its strokes facilitates free movements of the brush; since it is often illegible, it is mainly a decorative art. In order to gain an overview and a comparative sense of its possibilities, let us have a look at the character *Long* (dragon) as written in different ways by great masters of various periods.

*By the Tang dynasty poet Zhang Xiu*

*By the Tang dynasty poet Zhang Haohao*

*By the Song dynasty writer Huang Tingjiang*

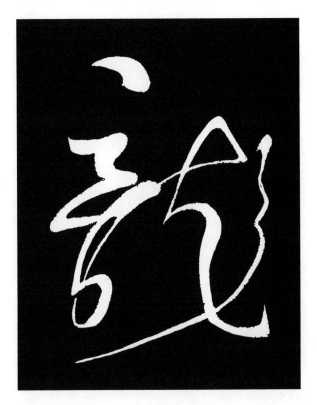

*By the Qing dynasty poet He Shaoji*

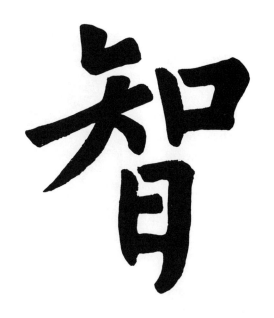

# 8 SEMI-CURSIVE SCRIPT

## *Xingshu*

*K*AISHU WAS COMPLICATED, and *Caoshu* almost illegible. These defects put off a great number of people. That is why rebellious intellectuals looked for and then created a new form of writing, combining the elegance of *Kaishu* and the ease of *Caoshu*. It was thus that *Xingshu* came into being—"cursive" Chinese writing that was more convenient and practical than *Kaishu*, and more legible than *Caoshu*.

*Xingshu* has another advantage that is not at all negligible. This

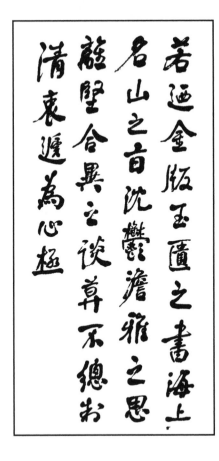

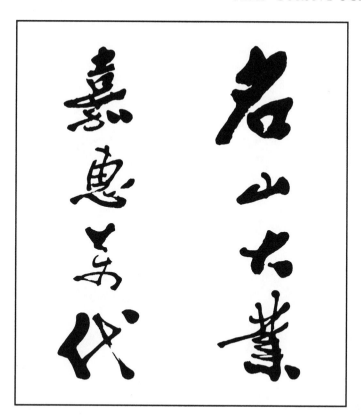

form of writing can be done as well with a brush or a pencil, or even a ballpoint pen, whereas *Kaishu* and *Caoshu* require a brush of good quality. Of course, it is far easier to use a pen than a brush.

With regard to the creator of *Xingshu*, there have always been two versions of the story. Most scholars think that this form of writing resulted from long-term efforts by anonymous calligraphers and even members of the common people. However, a small number of experts affirm that it

was Qiu Yanlian, a great calligrapher of the Jin dynasty (265–420 C.E.), who gave the original impetus to the invention of *Xingshu*.

Qiu Yanlian, a famous and popular poet who was a hermit, refused to accept all the honorific titles that the Jin emperors Xiaowudi and Andi tried in vain to bestow upon him. His preference was to live in a hut he had constructed by himself at the foot of Huishou Mountain, in the province Anhui in eastern China. He liked to go fishing at night and

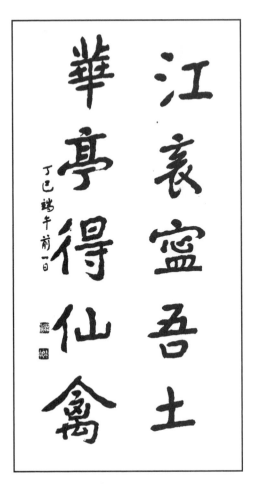

compose poems while drinking wine he made from his own rice crop.

He wrote his poems on the ground with a piece of bamboo, erasing with a swipe of his foot the words he didn't like and carefully revising each verse before copying the definitive text.

Nowadays, the Chinese make everyday use of *Xingshu*, and children in school learn this form

of writing, which then accompanies them throughout their lives.

It should be noted that, in fact, *Lishu, Kaishu, Caoshu,* and *Xingshu* all appeared at about the same time, that is to say, in the period between the end of the Qin dynasty and the middle of the Han dynasty. This was not purely a matter of chance, but a logical consequence of social and cultural developments.

In brief, before the unification of China by the first emperor Qin Shihuangdi in 221 B.C.E., the Chinese empire had passed through two major periods of war and social difficulties, which the historians have called the "The Spring and Autumn Period" (770–476 B.C.E.) and "The Warring States Period" (475–221 B.C.E.). This long phase of upheavals and changes was paradoxically very favorable for the circulation of people and ideas. Many feudal principalities of the time competed for people of talent, and encouraged any project that seemed likely to help assure the stability of daily life amid the turbulence of the ongoing wars. Thus, the intellectuals competed with intelligence and enterprise, creating many currents of thought, of which those of Confucius, Lao-tseu, Zhuang-tseu,

Xun-tseu, and others can make the glorious claim of having attained perennial status.

It is no surprise, then, that *Lishu*, *Kaishu*, *Caoshu*, and *Xingshu* were all born during this period of intense cultural activity.

Let us compare these four forms of Chinese writing, still living and in use in our times.

Like *Caoshu*, *Xingshu* is a big melting pot in which a large number of different styles have been forged.

| *Lishu* | *Kaishu* | *Caoshu* | *Xingshu* |

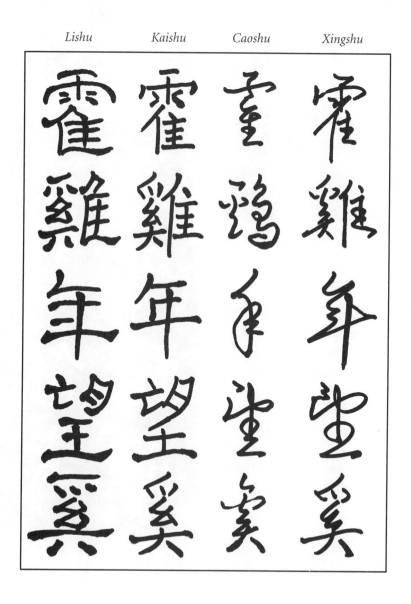

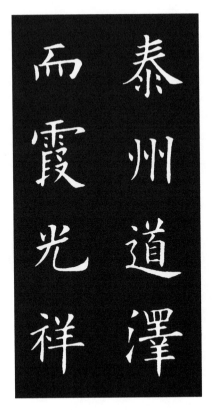

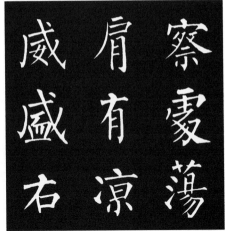

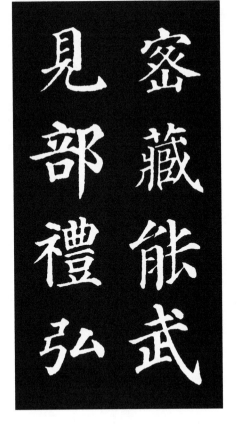

1. Regular Style

In the annals of Chinese calligraphy, the regular style occupies an important place, not only because—beautiful but difficult to execute—it has made famous the masters of calligraphy who have succeeded in replicating it, but also because it is still used as the basis of the exercises used to train future calligraphers.

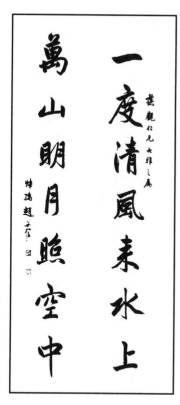

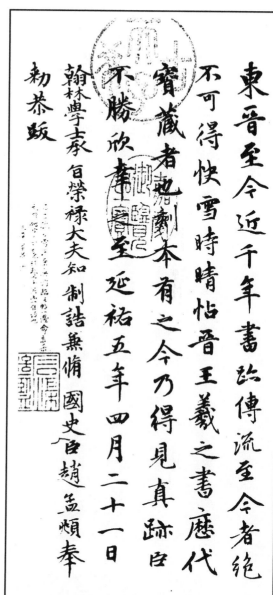

### 2. A Clear and Light Style

This style is characterized by refinement and lightness, especially in the curved strokes, which always end with a pointed and elegant finish. The calligrapher gains complete mastery of the ink as a result of repetitive exercises with a brush made of the hairs of young wolves.

The most important representative of this style is Zhao Mengfu, a minister of the emperor Ren-zong of the Mongol dynasty of the Yuan (1206–1368).

Here (above) is an excerpt from a text written by the emperor.

3. Heavy Style

This style made its appearance in the middle of the Tang dynasty, thanks to the poet Zhang Dan, who, in the course of a journey to Kunlun Mountain, spent the night at Qiyan Temple. The following morning, moved by the sight of the silhouettes of mountain ridges seen in the distance in the heavy mist, he wrote two verses in calligraphy on the wall with a broom soaked in cabbage milk. Since the worn broom was hard and did not respond as well as a brush to the energy and mood of the calligrapher, some of the strokes looked much bigger and thicker than others. The monk of the temple appreciated this calligraphy nonetheless and copied it on paper. This was the first copy of the heavy style of *Xingshu*. Below are two parallel sentences written in this style.

*Calligraphy by the Song dynasty emperor, Huizong*

4. Fine and Nervous Style

The emperor Huizong (reigned 1101–1119) of the Song dynasty (962–1279) was not only a talented poet but also a great master of calligraphy. From his childhood on, day and night he devoted himself to the teachings of his tutor Gan Miaoxia, who inculcated in him a highly developed sense of poetry and calligraphy.

When he was very young, the future monarch traveled from mountain to mountain, visiting many Buddhist temples, where he admired and imitated the writings inscribed on the walls by master calligraphers. Little by little, he de-veloped his own style, which he later called the "thin and vigorous style."

This style is distinguished by thin strokes that are nevertheless full of vigor and grace. The horizontal strokes end with a heavy brush stroke that gives force and beauty to the work. This style was very much appreciated by emperors and princes. Puije, the brother of Puyi, the last emperor of the last Chinese dynasty, the Qing (1616–1911), picked up the torch and distinguished himself by writing in calligraphy with brilliance and panache in this style, which my contemporaries like to call "the imperial style."

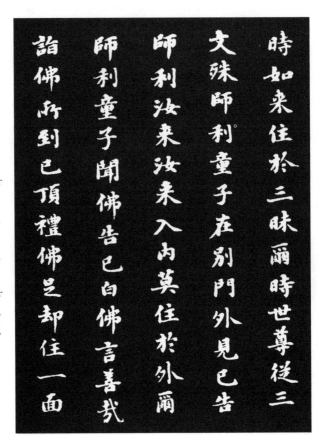

*An excerpt from the Sutra of the Entry into the Substance of the Kingdom of the Law (Dharma), written by the Liu Yong, a calligrapher of the Qing dynasty*

5. Buddhist Style

As a result of long years of copying out the Buddhist canonical scriptures, many Buddhist monks became great masters of calligraphy. In a serene atmosphere, calm and far from the world outside, they applied themselves to their copying with body and soul, working to attain beauty and legibility in their writing, while at the same taking great care for the durability of their precious copies, which had to stand up to the ravages of time. This is why the Buddhist style is very esthetic and exhibits strokes that are vigorous, distinct, and regular.

This Buddhist style is extremely difficult to execute attractively. It is necessary to practice tirelessly for years in order to acquire an adequate technique.

Let us look at some examples of this style in large characters (on the facing page):

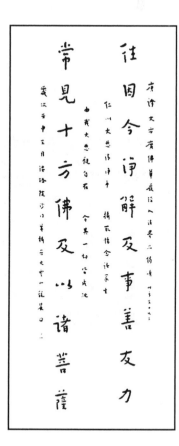

道
智
慧
理

### 6. Minuscule Style

In this style (below, left and right), somewhat thick strokes that come very close together can contain a certain force and esthetic order. What makes this style particularly difficult to master is the fact that the characters have to be placed quite close to each other, which demands arranging them in a very harmonious manner. Only a few great masters have ventured into this area.

7. Close Style

The strokes here are rather thick and are quite close together. They have a similar force and esthetic order to the minuscule style. Thus, the close style possesses the same artistic challenges and is as difficult as the minuscule style to master.

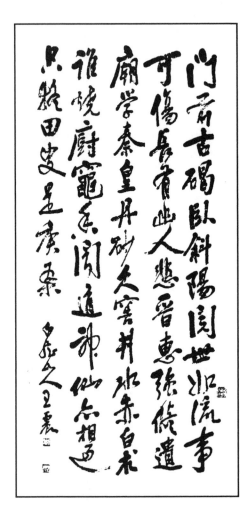

## 8. Square Style

Chinese characters are all square. But in the modern *Xingshu*, there is a rigorously square style intended for decoration, newspaper headlines, and all sorts of signs. Regular and clear, this style attracts attention through its power and austerity.

# 9 ABOUT THE ART OF CALLIGRAPHY

As we said in the Foreword, all Chinese are not calligraphers, and still less are they masters of calligraphy. Indeed, this art demands, in addition to long years of apprenticeship devoted to perfecting one's technique, a real talent.

Fifty years ago, school pupils, from the beginning of their schooling, took classes in calligraphy for two or three hours every day. This is no longer the case. Only students in fine arts schools, who are learning traditional painting, still devote their first year to the practice of calligraphy; for to become a painter of quality, it is indispensable to master this discipline.

## ARTISTIC VALUE

Chinese calligraphy shows an incontestable esthetic quality. For this reason, the Chinese—the intellectuals in particular—decorate their studies with one or two calligraphies executed on a silk scroll to imbue their houses with a refined and distinguished atmosphere. They also follow the custom of putting up on the two panels of their entry doors, or on either side of them, two parallel sentences written on two long pieces of red paper. These two phrases often express a wish for a good year, declare an aspiration of the master of the house, or simply show his desire to add a note of distinction to his house.

Below are two sentences inscribed on a lacquered panel:

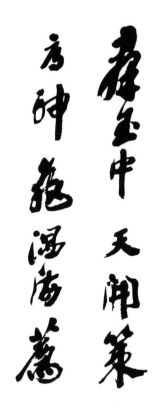

*"In a book, the mind is as vast as the sky. One swims in an ocean of wisdom."*

Here are two parallel phrases written on two long pieces of red paper pasted up on either side of the entry into an intellectual's study. They tell us:

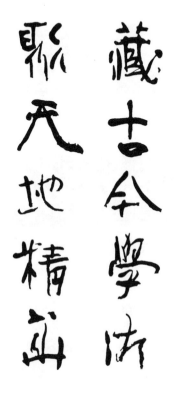

*"This study full of books both ancient and contemporary is a sea of wisdom."*

In ancient buildings, we frequently find that the main entrance door is backed by a high screen made of bricks. This is the case, for example, with the great portal of Zhongnanhai, the seat of the central Chinese government.

According to *Feng shui*, the best setup for a house is one in which the entrance door faces south, so that the beneficent rays of the universe can enter its courtyard and from there pass into the house. But there are also harmful currents in space from which it is necessary to protect the house by constructing a wall behind this door. The ancients decorated this screen with an enormous calligraphy expressing a wish.

This large character on a screen shows the aspiration of the master of the house and means:

Filial piety

As we have already said, the living room is an ideal place to put calligraphy. Chosen according to the taste of the master of the house, it expresses the soul of this dwelling place. Thus, during the Cultural Revolution, numerous intellectuals who were victims of the campaign of terror of the Chinese Communist Party

decorated their living rooms with two words drawn from a sentence engraved on a seal by the Zheng Banqiao, a great painter and calligrapher of the Qing dynasty. These two words, *Hu Tu*, meant, strictly speaking, "to be mindless" or "mentally absent," but in a figurative sense meant "closing one's eyes to reality." The Chinese intellectuals sought in this manner to manifest their opposition to the regime in power.

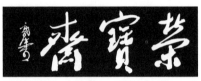

Logo of the oldest and best endowed fine arts museum

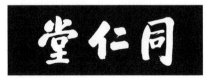

Logo of the oldest Chinese pharmacy, Tong Ren Tang

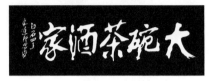

Logo of the great restaurant Da Wan Cha in Beijing

Often, children give their parents the gift of a calligraphy of the character meaning "longevity."

In China, store signs offer a calligraphic landscape that is at once attractive, seductive, and full of wit. Here, ingenuity and extravagance vie to produce the most sumptuous displays possible. Certain stores that were founded hundreds of years ago have even had their calligraphic logos registered with the National Bureau of Intellectual Property in order to protect them. Moreover, most of these logos have values in the many thousands of dollars.

## SYMBOLIC VALUE

The Chinese also use calligraphy as a talisman. That is why in all regions of China, both in the city and in the country, people have the custom of writing on their door lintels auspicious words, such as happiness, longevity, good harvest, prosperity in business, etc. Such calligraphies can also be seen in Paris, for example, in the

Chinese and Vietnamese communities. They are decorative and symbolic at the same time, because according to the Chinese tradition, they bring honor, both to the place where they are exhibited and the person it belongs to.

家如東海

1. *Fu Ru Dong Hai* (Happiness)

寿比南山

2. *Shou Bi Nan Shan* (Longevity)

五谷丰登

3. *Wu Gu Feng Deng* (Good Harvests)

生意兴隆

4. *Sheng Yi Xing Long* (Prosperity in Business)

招财进宝

5. *Zhao Cai Jin Bao* (Enrichment)

身体健康

6. *Shen Ti Jian Kang* (Good Health)

家庭和睦

7. *Jia Ting He Mu* (Good Understanding in the Family)

喜囍

8. *Ji Xiang Ru Yi* (Auspicious Prediction)

大展鴻圖

9. *Da Zhan Hong Tu* (The Future)

## VIRTUE FOR PHYSICAL THERAPY

As a result of their experience, master Chinese calligraphers advocate a high level of mental concentration and, therefore, an environment that is calm and serene to work in.

A high level of concentration implies mastery of the breath, a conscious control of movements, and the ability to empty oneself of thoughts that might trouble the mind and the energy of the hand. This represents a discipline that one also finds among masters of the martial arts, masters of *Qi Gong*, and masters of *Taijiquan*.

Traditional Chinese medicine even considers the practice of calligraphy an effective therapeutic remedy for certain illnesses, such as migraine, insomnia, digestive difficulties, stress, and so on. This health-enhancing practice is often called "calligraphotherapy." A great number of Chinese retirees devote themselves to it with enthusiasm for one or two hours a day.

## SEALS

Every Chinese person possesses a seal with his first and last name on it that serves as his signature. The seal made its appearance more than three thousand years ago. According to an expert in this field, Lin Shuqing, the first seals were inscribed on the earth.

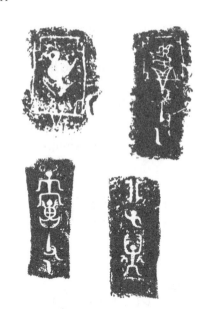

*Copper seals from the Shang dynasty*

*Four Seals from the Shang dynasty (c. 1750–1040 B.C.E.) discovered by our archeologists*

Under the Han dynasty, the practice began with carving characters in wood to make seals. It is interesting to note, moreover, that the artisans of that period already made use of this means to mark their products. For example, round tiles have been discovered with the artisan's names or marks on them:

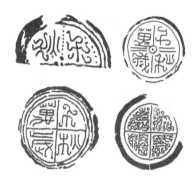

The development of this art was a very slow one. In fact, it only really began to flourish at the end of the Mongol dynasty of the Yuan, when Wang Mian had the idea of making seals with a special kind of stone found in the district of Qingtian, in the province Zhejiang. This is a soft, very tender stone, which in contrast to copper, is easy to carve. The idea was launched and immediately had great success. The art of seals, quickly put to use by kings, princes, and emperors, was a derivative of calligraphy, and it in turn contributed to the further development of calligraphy, with the result that the two arts became mutually enriching.

Seals naturally became decorative objects that were very prized by painters and calligraphers, who used them to identify and embellish their works. It is unthinkable for a work of Chinese painting or calligraphy to be presented with-

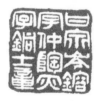

*Four personal seals*

out impressions of one, two, or several of the author's seals.

In conclusion, we should state that most of the seals, ancient or modern, bear characters of *Jinwen*, *Xiaozhuan*, and *Lishu*, and this confers a kind of classical beauty on them. The Chinese, especially the intellectuals, adore this redolence of ancientness, which is emphasized further by the use of dark red ink.

## THE FOUR TREASURES OF A CALLIGRAPHER'S STUDY

Any Chinese calligrapher must have in his possession a set of the instruments that are indispensable for the exercise of his art. The essential equipment is composed of four elements.

*Seal of the emperor Gaozong of the Qing dynasty*

## 1. Brush

This is the first treasure found in the studies of Chinese intellectuals. The brush exhibits several qualities, depending on the kind of hair it is made from. The quality of first choice is a brush made from the hair of a newborn child. Following that, in decreasing order of quality, are brushes made with hair of a weasel or a fox, the rabbit's-hair brush, and finally, the most common, a brush made with sheep's hair. The smallest brushes weigh only a few grams, and the biggest weigh several hundred kilograms. These latter are used when a calligrapher must draw characters several tens of meters in size. They must be suspended from a scaffold to be used.

The Chinese brush is a special kind of object. Numerous documents and archives indicate that the first inscriptions inscribed on the bones and the shells of tortoises *(Jiaguwen)* were originally drawn in ink with a brush and only later carved with a knife. This tells us that the brush is one of the most ancient of inventions, going back to about the sixteenth century B.C.E.

According to certain specialists, the most celebrated brush is the *Zhugebi* brush, the size, thickness, and suppleness of which is extremely variable, making possible calligraphy in all kinds of styles. On the Chinese continent, as well as on the island of Taiwan, Chinese calligraphers generally use brushes made from the hair of the goat, the wolf (or weasel), or "purple hair" (from the rabbit).

## 2. Ink

In the beginning, ink existed in the form of a stick made from all kinds of minerals mixed with glutinous rice and the ashes of perfumed incense. The best ink is that of *Li Tinggui*, which assures fluidity, sheen, harmony of thickness, and good absorption by the paper.

These sticks can be finished more and more beautifully, to the point where they become a sophisticated work of art, imprinted with designs and artistic characters in different colors.

Nowadays, in order to facilitate their work, calligraphers also use black liquid ink, which is generally mediocre in quality. But in addition to this, every master of calligraphy possesses a personal recipe that provides him with an ink that corresponds to his artistic temperament. For example, often a certain number of mineral pigments are added to the liquid ink.

### 3. The Ink Stone

Calligraphers put a great deal of emphasis on the quality of their ink stone. The best ink stone is that of *Duan Xi*.

The ink stone is a very special kind of stone, of a fine and tender texture, very soft to the touch. With these qualities, it is easy to shape, capable of being finely sharpened so as to facilitate the rubbing of the ink stick, and its soft texture also protects the hairs of the brush.

The ancients like to inscribe their names and poems on their inks stones. Thus, the ink stones became precious objects and a personal adornment of the calligrapher's study. Calligraphers also take great pleasure in rubbing the ink stick on the hollow moist stone in infinite circles, thus creating an atmosphere of concentration favorable to the calligraphic process. This rubbing produces a particular type of sound that depends on the quality and composition of the ink stone. This is why the prices of ink stones can vary greatly.

As an object of art, the ink stone presents an esthetic dimension that increasingly attracts collectors. Today, the ink stones used by the emperors of different dynasties of the Empire of the Middle are extremely rare and sought after.

Some of them are ornamented with sculpted dragons and have a marble cover also carved with many dragons flying through the clouds. The biggest ink stone weighs more than two tons.

### 4. Paper

Paper was invented by the Chinese, more precisely, by Cai Lun of the Eastern Han dynasty (25–220). The best paper for Chinese calligraphy is known as *Xuanzhi*, also simply called rice paper. *Xuanzhi* is a special paper prized not only by calligraphers but also by Chinese painters because of the very special way it takes ink.

*Xuanzhi* is made by hand and is known for its quality. It is very soft, yet tough, and provides the right degree of ink absorption demanded by masters of calligraphy. As we are told by an old Chinese proverb, "In order to do good work, it is above all necessary to have a good tool." The four treasures of the study of the Chinese literati are a set of materials that has accompanied the evolution toward perfection of the art of calligraphy throughout its long development. It could even be said, without exaggerating too much, that these treasures make possible the best expression of the thoughts and feelings of the

Chinese people and enable the perpetuation of its culture.

# THE SIMPLIFICATION OF CHINESE WRITING

The simplification of Chinese writing has always gone hand in hand with its evolution and continues to do so. The characters originally had a form and construction that was too complicated and contained too many strokes to be popularized. Over the course of history, the intellectuals have tirelessly sought to make this writing easier, and this need has been a major spur to their creativity in the work of simplifying words.

In the modern sense of the term, the simplification of Chinese writing alludes to the campaign of reform undertaken by the Chinese Communist Party beginning in the 1950s, after it took over the central power. At the present time, two forms of writing exist: the simplified form used on the Chinese continent and in Singapore, and the nonsimplified form in use on the island of Taiwan and in all the other Chinese communities across the world.

This reform campaign on the part of the Chinese Communists began in 1956, the year in which the National Commission for the Reform of Writing published a long list of 1,700 simplified characters. And since then, in 1964, the same commission put out another general list of simplified characters, this time numbering 2,238.

This simplification consists in the first place in reducing considerably the number of strokes in a great many of the characters that were too complicated; and, in the second place, in replacing a limited number of words by their homophones; and finally, in getting rid of superfluous variants (since certain characters had several different forms).

This simplification has two sides to it.

Of course, it has the obvious advantage of making the writing of everyday life easier. It makes writing easier to learn. It makes it easier to put out newspapers and books, to do all kinds of printing on paper, and so on. But at the same time, it inevitably destroys the images of certain pictograms and, as a result, the beauty of Chinese writing. This is why not all calligraphers accept this reform.

The Chinese of Hong Kong, and especially those of Taiwan and the "Chinatowns" in foreign lands, have always rejected this

simplification and have continued to use the nonsimplified characters. In the 1960s, an editor in Taiwan was even punished for adopting the system of simplified characters instituted by the Communists on the continent.

It remains to point out that the simplified characters are generally written and printed horizontally, from left to write, whereas most of the time the nonsimplified characters are arranged vertically, from right to left.

It should also be noted that, from the dawn of civilization, the ancients adopted certain simplified characters for their cursive writing that the moderns have taken over from them. A certain number of simplified forms have been found in the archeological archives that date to the third century B.C.E.

| Nonsimplified Characters | Simplified Characters | Nonsimplified Characters | Simplified Characters |
|---|---|---|---|
| 蕩 | 荡 | 開 | 开 |
| 處 | 处 | 運 | 运 |
| 禮 | 礼 | 萬 | 万 |
| 飛 | 飞 | 寶 | 宝 |
| 遷 | 迁 | 劃 | 划 |
| 陽 | 阳 | | |

# CONCLUSION

THE EVOLUTION of Chinese writing has traveled a very long road, whose meanderings are many and often cross each other. In order be able to provide a kind of overview of this labyrinthine journey, we have had to stick to its main route, limiting ourselves to presenting the seven main levels of evolution.

Following this same principle, we consider it useful to show at the end of this work a few examples of words executed according to these different styles of writing.

| Devil | Angle | Elephant |
|-------|-------|----------|

*Jiaguwen*

*Jinwen*

*Xiaozhan*

*Lishu*

*Kaishu*

*Caoshu*

*Xingshu*

| Research | Fountain | Jug | |
|:---:|:---:|:---:|:---|
| | | | *Jiaguwen* |
| | | | *Jinwen* |
| | | | *Xiaozhan* |
| | | | *Lishu* |
| | | | *Kaishu* |
| | | | *Caoshu* |
| | | | *Xingshu* |

|  | Tripod | Defense | Shield |
| --- | --- | --- | --- |
| *Jiaguwen* | | | |
| *Jinwen* | | | |
| *Xiaozhuan* | | | |
| *Lishu* | | | |
| *Kaishu* | | | |
| *Caoshu* | | | |
| *Xingshu* | | | |

| Peace | To pick, gather | Prime Minister | |
|-------|-----------------|----------------|---|
| | |  | *Jiaguwen* |
| | | | *Jinwen* |
| | |  | *Xiaozhuan* |
| | | | *Lishu* |
| | |  | *Kaishu* |
| | | | *Caoshu* |
| | |  | *Xingshu* |

# APPENDICES

## Chronology of the History of China

| | |
|---|---|
| XIA DYNASTY | c. twenty-first to sixteenth century B.C.E. |
| SHANG DYNASTY | c. 1750–1040 B.C.E. |
| ZHOU DYNASTY | |
| Western Zhou Dynasty | c. eleventh century–771 B.C.E. |
| Eastern Zhou Dynasty | 770–256 B.C.E. |
|    Spring and Autumn Period | 770–476 B.C.E. |
|    Warring States Period | 475–221 B.C.E. |
| QIN DYNASTY | 221–206 B.C.E. |
| HAN DYNASTY | |
| Western Han Dynasty | 206 B.C.E.–23 C.E. |
| Eastern Han Dynasty | 25–220 |
| THREE KINGDOMS | |
| Wei Kingdom | 220–265 |
| Shuhan Kingdom | 221–263 |
| Wu Kingdom | 222–280 |
| JIN DYNASTY | |
| Western Jin Dynasty | 265–316 |
| Eastern Jin Dynasty | 317–420 |
| SOUTHERN AND NORTHERN DYNASTIES | |
| Southern Dynasties | |
|    Song | 420–479 |
|    Qi | 479–502 |
|    Liang | 502–557 |
|    Chen | 557–589 |

Northern Dynasties
    Northern Wei               386–534
    Eastern Wei             534–550
    Northern Qi              550–577
    Western Wei            535–557
    Northern Zhou        557–581

SUI DYNASTY           581–618

TANG DYNASTY        618–907

FIVE DYNASTIES
Later Liang             907–923
Later Tang             923–936
Later Jin               936–947
Later Han              947–950
Later Zhou             951–960

SONG DYNASTY
Northern Song Dynasty    960–1127
Southern Song Dynasty    1127–1279

LIAO DYNASTY        907–1125

JIN DYNASTY          1115–1234

YUAN DYNASTY        1271–1368

MING DYNASTY        1368–1644

QING DYNASTY         1644–1911

REPUBLIC OF CHINA    1912 (from 1949 in Taiwan)

PEOPLE'S REPUBLIC
OF CHINA               1949 (in continental China)

# BIBLIOGRAPHY

Chang, Leon. *Four Thousand Years of Chinese Calligraphy*. Chicago: University of Chicago Press, 1990.

Fazzioli, Edoardo. *Chinese Calligraphy: From Pictograph to Ideogram*. New York: Abbeville Press, 1987.

Fu, Shen. *Traces of the Brush: Studies in Chinese Calligraphy*. New Haven: Yale University Art Gallery, 1977.

Harrist, Robert, and Wen Fong. *The Embodied Image: Chinese Calligraphy from the John B. Elliott Collection*. Princeton: The Art Museum, Princeton University, 1999.

Hwa, Khoo Seow, and Nancy Penrose. *Behind the Brushstrokes: Appreciating Chinese Calligraphy*. Hong Kong: Asia 2000 Ltd., 2000.

Ledderose, Lothar. *Mi Fu and the Classical Tradition of Chinese Calligraphy*. Princeton: Princeton University Press, 1979.

McNair, Amy. *The Upright Brush: Yan Zhenqing's Calligraphy and Song Literati Politics*. Honolulu: University of Hawaii Press, 1998.

Nakata, Yujiro, trans. J. Hunter. *Chinese Calligraphy*. New York: Weatherhill, 1983.

Tseng, Yuho. *A History of Chinese Calligraphy*. Hong Kong: The Chinese University Press, 1993.

Yee, Chiang. *Chinese Calligraphy: An Introduction to Its Aesthetic and Technique, 3rd ed.* Cambridge: Harvard University Press, 1973.

*I would like to express special thanks to the library of the Centre culturel et d'information de Taipei in Paris, which was kind enough to allow me to consult its rich collection of documents related to Chinese writing.*

*Writing's Perfume*

*Chinese Calligraphy*